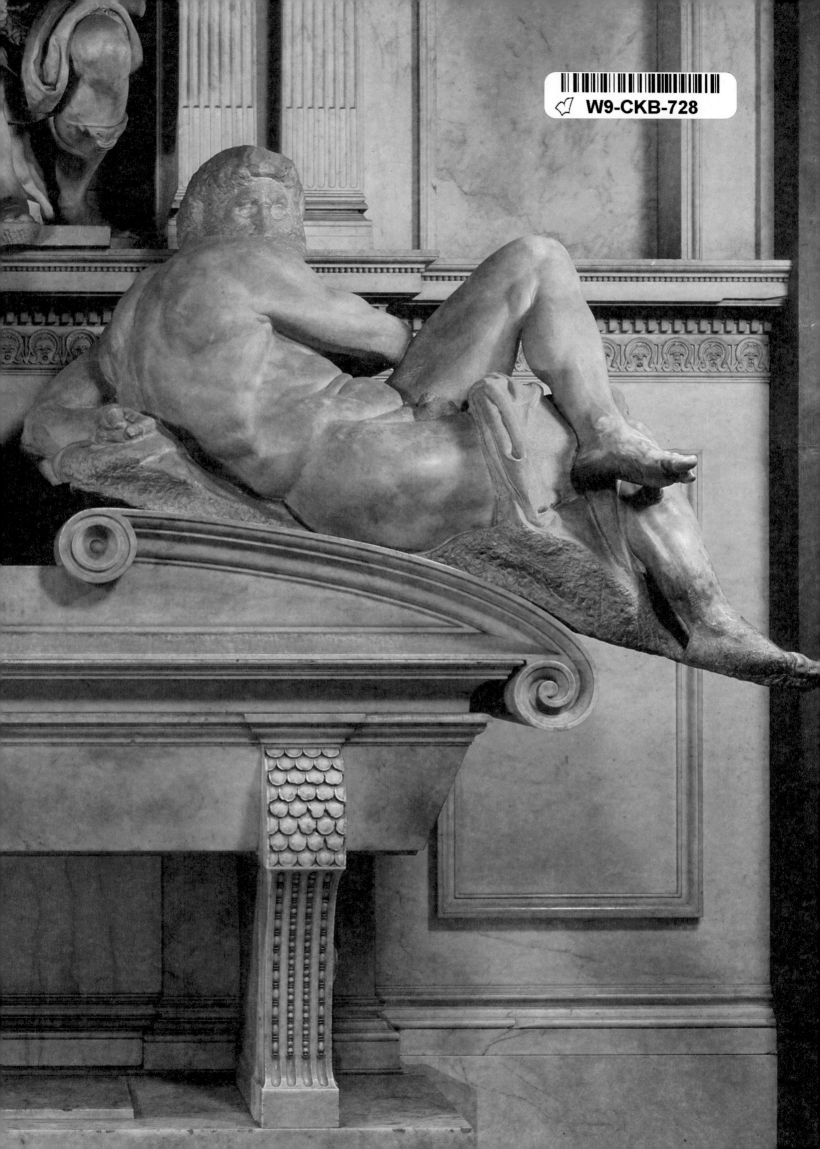

THE ART OF
MICHELANGELO

THE ART OF
MICHELANGELO
Nathaniel Harris

GALLERY BOOKS
An Imprint of W. H. Smith Publishers Inc.
112 Madison Avenue
New York City 10016

First published in Great Britain in 1981 by
The Hamlyn Publishing Group Limited

This edition published in 1989 by Gallery Books
an imprint of W.H. Smith Publishers Inc.
112 Madison Avenue, New York City 10016

Copyright © 1981 The Hamlyn Publishing Group Limited

ISBN 0-8317-5934-8

Produced by Mandarin Offset
Printed and bound in Hong Kong

Contents

Michelangelo: an Introduction

Alone among artists, Michelangelo is widely looked upon as a species of superman. This impression arises from the impact of his works and is reinforced by examining the known facts of his life. He tackled single-handedly the kind of tasks that others approached with teams of assistants: painting the vast ceiling area of the Sistine Chapel with a multitude of figures, carving literally colossal statues, and directing work on the largest church in Christendom. When he was overtaken by death, at the age of eighty-nine, he was still creating masterpieces. His painted and sculpted figures of men and women are themselves superhuman in beauty, strength and energy, and live exclusively on the high heroic plane. God creates Adam with the life-charged touch of a fingertip; the mother of Christ mourns her dead son who lies across her lap; the boy David, symbolic of republican virtue, stands ready to smite the Philistine; a duke broods over his own tomb above languorous figures of Dusk and Dawn. Despite the variety of his subjects, Michelangelo endows them with a unifying intensity of feeling that excludes the trivial, the light-hearted, even the ordinary and everyday; the most passive of qualities, such as languor, is rendered with an expressive force that raises it to a near-ecstatic condition. Michelangelo's world is one of cosmic and mythic dimensions, entirely appropriate to the godlike creator whom his own contemporaries hailed as 'the divine Michelangelo'.

He also seemed godlike in the universality of his genius. He was a child of the Renaissance, a dynamic age that believed the 'universal man' to be both possible and desirable; but though other men of that age displayed as wide a range of talents as Michelangelo, none approached his achievements in more than one field. He was an architect and poet of real importance – and a painter and sculptor of supreme importance. As either painter or sculptor he would rank among the three or four greatest in history, a double distinction that is unique in the entire record of Western art. This is implicit in a comment made by a contemporary Italian writer, the vitriolic Pietro Aretino, who took exception to Michelangelo's mock modesty. When his friends praised his paintings in the Sistine Chapel, says Aretino, Michelangelo would declare that he was actually a sculptor by trade; when they admired his carvings on the Medici tomb, he would murmur that he was really a painter! Aretino's point was nicely made, but it could not have been made of any other artist.

Michelangelo was a late-comer, not a pioneer. By the time of his birth in 1475, the Italian Renaissance was already two hundred years old as a movement in the arts, and had produced an astonishing number of men of genius – great painters from Giotto to Leonardo da Vinci, great sculptors from Nicola Pisano to Donatello, great architects from Brunelleschi to Leon Battista Alberti. They had effected a transformation in the visual arts, as Giorgio Vasari recognized when he published *The Lives of the Most Excellent Painters, Sculptors and Architects* in the mid-16th century. This book celebrates the achievements of the Renaissance artists, and its very existence was an indication of the seriousness with which art and artists had come to be taken. Yet Vasari, writing while Michelangelo was still alive, made his biography the climax of the whole work. Despite the praise he lavished on earlier artists, he proclaimed that God had

> looked down on men and, perceiving the futility of all their attempts . . . resolved to rid them of their errors by sending into the world a being supreme in every art. Single-handed, this genius would achieve perfection in line and modelling, creating three-dimensional effects in painting, demonstrating right judgement in sculpture, and designing buildings that would be functional, safe, pleasant, well-proportioned, and richly ornamented.

Furthermore this artist was to possess true moral philosophy and the gift of poetic expression, so that everyone would be willing to follow his example, 'and

Italian school. Bronze head of Michelangelo; mid-16th century. Musée du Louvre, Paris.

6

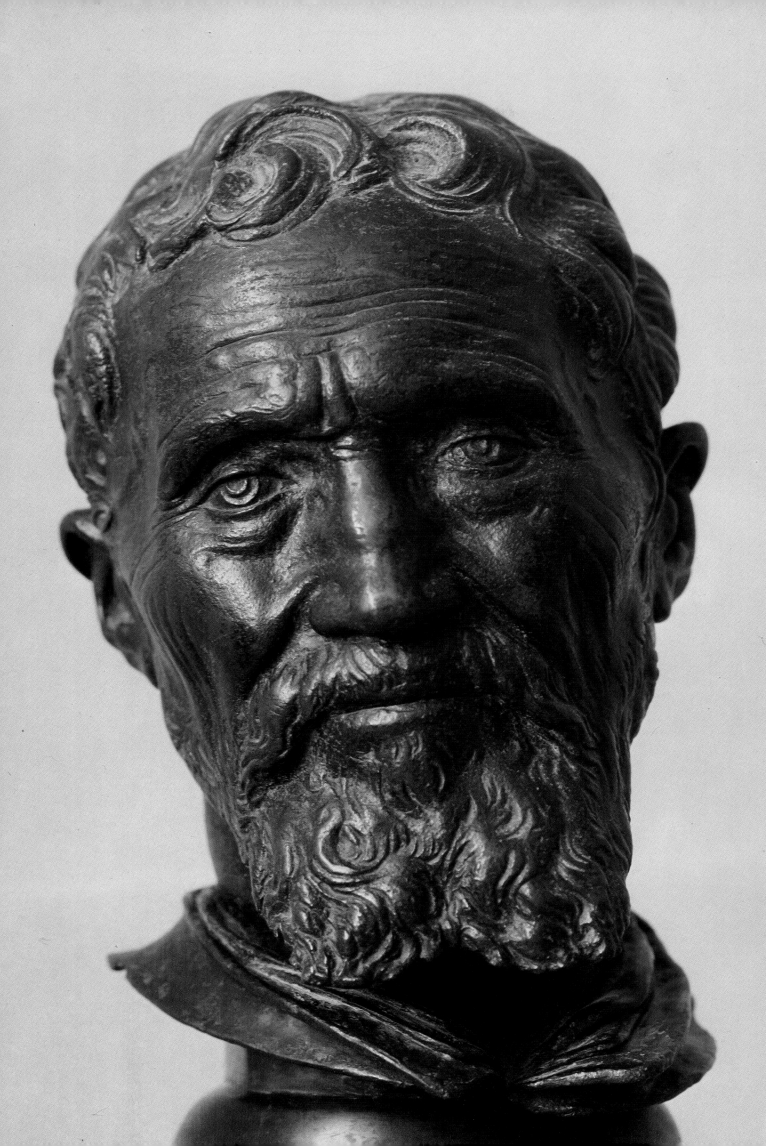

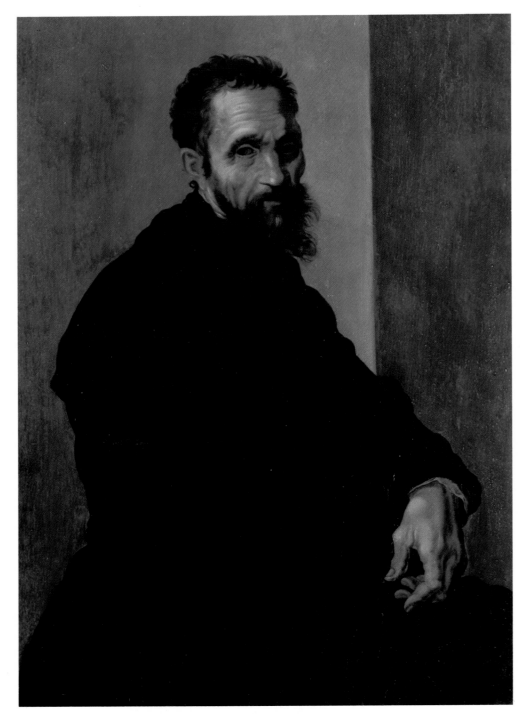

Portrait of Michelangelo. *c*.1540. This well-known portrait of Michelangelo is ascribed by some to Jacopino del Conto and thought by others to be a self-portrait. Casa Buonarotti, Florence.

he would be acclaimed as divine'. The 'divine' being was, of course, Michelangelo.

Most of Michelangelo's contemporaries felt the same way; even such a relentless egoist as Benvenuto Cellini, who wrote the first autobiography by an artist, drops his boastful manner and refers to Michelangelo with worshipful humility. Those who met him were reduced to a kind of nervous awe on account of his *terribilità*, a word that conveniently described the majestic, turbulent quality of Michelangelo's art and his intimidating personality, which included an all-too-human aptitude for scathing remarks and a tendency to fly into rages. In fact Michelangelo exhibited many characteristics of the legendary 'temperamental genius'. He was quarrelsome, independent, utterly single-minded and therefore, on occasion, absent-minded; in old age he sometimes forgot to take off his boots for such long periods that, when he did so, pieces of his skin came away with the leather. He may well have been the first 'genius' in another sense – that he was the first artist to be regarded as a privileged being rather than as a craftsman who was expected to behave himself and execute such commissions as patrons might be good enough to entrust him with. Michelangelo's older contemporary, Leonardo da Vinci, achieved a greater degree of independence than most artists, and was treated with respect despite – or perhaps because of

– his infuriating combination of genius and unreliability; but he was always uncomfortable without a patron and protector, and was sometimes reduced to writing humble letters to prospective employers. By contrast, Michelangelo was never in serious need of patronage and worked for the great men of his time at their earnest entreaty; in the most notorious instance, Pope Julius II had to argue him into submission before he would undertake to paint the Sistine Chapel. By middle age, Michelangelo was more than a great artist whose moods and idiosyncrasies were generally tolerated; he was a semi-sanctified figure whom even the most distinguished of his contemporaries were prepared to pester for any scrap of a drawing he might condescend to give them. It would not be an exaggeration to say that, for men like Vasari, Michelangelo became the supreme divinity in the religion of art.

Michelangelo's lifetime (1475 – 1564) spanned the High Renaissance, which represented a grand climax of virtuosity and grandeur in the arts, and extended into the post-Renaissance age of ebbing confidence and rule-bound academies. Both phases of development were beset with new tensions and anxieties, and in this respect art merely reflected the wider life of Italy. Among other things, the humiliations experienced by Italians at the hands of foreign armies, the religious crisis caused by the emergence of Lutheran Protestantism in Germany, and the growth of authoritarianism in politics, religion and thought, undermined Renaissance values and destroyed Renaissance optimism. Even Michelangelo's early sculptures have an inwardness – a sense of anxiety or conflict or struggle – that is distinct from expressed emotion and is new in the history of art; and this became more marked over the decades. Part of his greatness, as we shall see, lay in his ability to develop further, responding to the tensions of the age in his own fashion and moving from the troubled heroism of *David* to the apocalyptic grandeurs of the *Last Judgement*.

Filippo Brunelleschi. The nave of the church of San Spirito, Florence, looking east. 1432. Designed by a great Florentine architect, it was a Renaissance building of a new type, breaking with the medieval Gothic style.

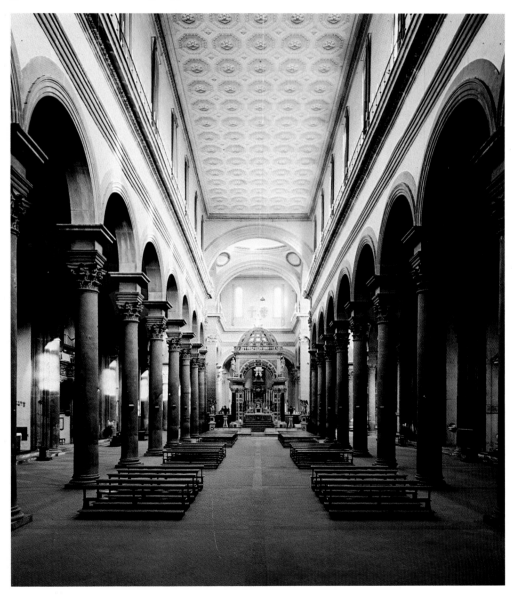

The World of Michelangelo

In terms of geography, Michelangelo's world was tiny. Virtually his entire life was spent in the Italian cities of Florence and Rome, which were only 233 kilometres apart and boasted a joint population of less than 100,000 souls. Michelangelo knew the rest of the world by report alone; he never visited other lands, and never even saw the southern half of the Italian peninsula. His genius owed nothing to the supposedly broadening effects of travel or the stimulus of unfamiliar sights.

On the other hand, Michelangelo's tiny world was probably the most vital spot in Europe. Culturally, Florence had been the leading city in Italy for most of the Renaissance, and was to be succeeded by Rome during the early decades of the 16th century. Italians looked down on other nations as 'barbarians' who were still living in a gloomy medieval twilight, for Italy alone, they held, had witnessed a rebirth ('re-naissance') of civilization as it had flourished under the ancient Greeks and Romans. Repudiating the medieval tendency to believe that the world was a vale of tears, Renaissance Italians sought to develop human potentialities in life, art and thought; optimism and ambition in the pursuit of human excellence became the most admired of secular qualities. In the arts of life, Greek and Roman – 'classical' – models reigned supreme; Renaissance man sedulously imitated the ancients, modelling his Latin prose on Cicero, working out his political ideas by referring to the Greek city-state or the Roman Empire, making Plato the starting point for his philosophy, and even translating Christian terminology into the hallowed pagan Latin of the classical authors. But this in no way implied a rejection of Christianity. The Renaissance expanded rather than shifted man's conciousness, so that he now aspired to be elegant, eloquent, good-mannered and accomplished in numerous other respects *as well as* to be a good Christian. Both the classical and the Christian influences were strong in Michelangelo's art, and in some works they are curiously juxtaposed, but there can be no doubt that his ardent religious faith was the central fact of his existence.

In the arts, Michelangelo's native Florence produced most of the major figures of the Early Renaissance, beginning with Cimabue and Giotto, who brought a new sense of humanity and drama to religious painting. This was to remain the central tradition of Renaissance art, expressing itself in a zealous quest for greater naturalism; to achieve an illusion of human solidity and three-dimensionality, artists studied anatomy and perspective, in some cases to the point of obsession. The 'rightness' of naturalism seemed confirmed by the little that was known of ancient painting and the more abundant evidence of Greek and Roman sculpture, in which Michelangelo displayed a life-long interest amounting to a passion. Excavations and accidental discoveries of ancient statuary were discussed with intense enthusiasm by connoisseurs and artists alike, providing exciting new ideas for subjects and treatments. (Down to recent times, novelty has not been particularly admired or confidently attempted in the arts, and 'avant-garde' work has often been stimulated by contact with alien or outmoded forms. For example, Michelangelo was encouraged to depict frenzied movement by studying the newly-discovered *Laocoön* group, just as Picasso was encouraged to paint his epoch-making *Demoiselles d'Avignon* by seeing African masks.) Above all, the Greek and Roman example gave Italian painters and sculptors the courage to introduce the naked human body into the art of the Christian West – and to exhibit it in the classical spirit, as the most glorious and powerful of created things. The heroic nude manifested itself in splendour during the 15th century, notably in the works of the great Florentine sculptor Donatello, but it achieved an undreamed-of majesty in the hands of Michelangelo, who made it the principal subject of his art.

The cultural achievements of the Italian cities were made possible by their wealth and sophistication; in fact, the quality of Italian urban society, like the

Cimabue. *Madonna and Child Enthroned.* Cimabue (*c.*1240–1302?) is often considered the first great painter of the Renaissance. The progressive humanizing of religious art can be followed by comparing this painting with the works by Masaccio, Donatello and Michelangelo illustrated in this book. Galleria degli Uffizi, Florence.

art to which it gave rise, had no real counterparts in the rest of Europe. Significantly, Florence was one of the wealthiest Italian cities, thriving on trade in textiles and silks, and becoming an international financial centre. Like so many Italian cities, it had successfully maintained its independence during the Middle Ages and functioned as the ruling capital of a larger territory; the division of the peninsula into city-states – Florence, Venice, Mantua, Urbino and so on – gave Italian culture a broad base and a healthy variety of traditions, although there was always a danger that it might become a source of political weakness.

Florence was nominally a republic, but for most of the 15th century it was controlled by a single family – the Medici. Their chief assets were a banking house with branches or agencies over most of Europe, and a family tradition of political tact. The banking house brought them enormous wealth and prestige; the political tact prompted them to avoid offending Florentine vanity by controlling the city from behind the scenes. The effective founder of the dynasty, Cosimo de' Medici, exercised power in this fashion for over thirty years. He was a discriminating patron of the arts, but was surpassed in this by his grandson Lorenzo the Magnificent. Lorenzo, himself no mean poet, formed a private court of writers and artists which, in periods of leisure, he would transport to a countryside retreat; there, in arcadian settings, the talk would be devoted to literature, myth, and a high-minded, rather cloudy philosophizing derived from the Greek Platonic tradition. Not the least of Michelangelo's strokes of good fortune was to have been taken up by Lorenzo while the artist was still in his teens.

Soon after Lorenzo's death in 1492, the Medici were expelled and a genuine republic was set up; but the great days of Florence proved to be over. The Italian cities had flourished splendidly – and quarrelled and fought with one another, and developed delusions of grandeur – during the long period when Italy was safe from outside interference. This came to an end in 1494, when a French expedition across the Alps brought the conflicts of the great powers to the peninsula and revealed the weakness of the puny city-states. Florence, like others, suffered humiliations and was eventually forced to take back the Medici – now not as first citizens but as autocratic dukes who were under Imperial protection.

Before most of this occurred, Michelangelo had gone to Rome and had begun his titanic labours for Pope Julius II. Not only Michelangelo, but the painter Raphael of Urbino, the architect Bramante and a host of other highly gifted artists congregated in the city and made it the new centre of the Renaissance. Under Julius it also gave heart to the rest of Italy, for this remarkable warrior-pope succeeded, for the time being, in ending the foreign threats to the Italian states. His actions were a little less extraordinary than they sound in our modern ears, for in the 16th century the pope was a powerful secular ruler as well as a spiritual leader. He controlled not only Rome but extensive territories lying across central Italy and, perhaps inevitably, his behaviour was not notably different from that of other earthly princes in the spheres of statecraft, war and diplomacy. This secular involvement of the papacy (which was in fact curtailed only during the 19th century) was an important factor in many of the triumphs and disasters that affected Rome in Michelangelo's lifetime.

The city of Rome itself was charged with deep emotional significance for the men of the Renaissance. They revered it as the sometime capital of the Roman Empire, where the ruins of antiquity (the Forum, the Colosseum, triumphal arches) could still be visited; and as the capital of the popes, who claimed spiritual dominion over Christendom from the very place in which St. Peter and St. Paul had been martyred. After Roman times the city had lost much of its outward glory, and its broken walls encompassed large areas of waste, vineyards, ruins, and a multitude of churches; the population, which had reached a million in antiquity, sank to about 40,000 in the later Middle Ages. But a transformation began in the mid-15th century and continued at a greatly accelerated rate during Michelangelo's lifetime. He himself made a substantial contribution to it with his paintings in the Sistine Chapel, his re-designing of the ancient Capitol and his work on St. Peter's, the greatest of all papal building projects. Papal largesse brought artists flocking to Rome, and the cardinals followed the example of their superior, building splendidly designed and decorated palaces, and living in great pomp and luxury.

Though still economically insignificant, Rome became a city of marble, of festivities and banquets, of cosmopolitan culture and wonderful art.

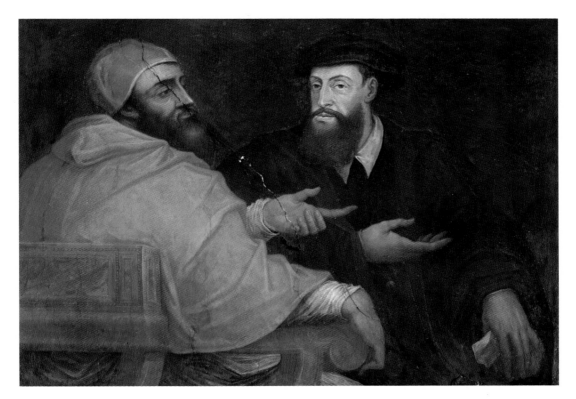

Giorgio Vasari. *Pope Clement VII with the Emperor Charles V*. Though shown as amicable enough here, Pope and Emperor had quarrelled in the 1520s, an event that led to the disastrous sack of Rome in 1527. As well as being a highly successful painter, Vasari wrote the first collection of artists' biographies, making the life of Michelangelo the climax of the entire work. Palazzo Vecchio, Florence.

Italians generally admired the achievements of popes such as Julius II, who personally led armies, and Leo X, who lavished the papal revenues on poets, singers and St. Peter's. Elsewhere, many people felt that war, culture and extravagance ought not to be the principal concerns of the Church. Resentment about the way in which papal revenue was spent became indignation about the way it was raised – under Leo X by the shameless sale of any office in the Church, and by the sale of Indulgences (documents promising forgiveness of sins) to the faithful. It was the Renaissance papacy – whose patronage brought into being so many of the glories of Western art – that provoked the Protestant Reformation led by the German monk Martin Luther. Although few Italians responded to the new doctrines, the challenge of Protestantism would probably have caused a change of outlook in Renaissance Italy even if events – the papal involvement in war and diplomacy as much as religious questions – had not ensured that such a change should take place. In 1527 Pope Clement VII was at odds with Charles V, Holy Roman Emperor and King of Spain. Charles invaded Italy, his troops got out of hand, and a mixed Imperial force of Catholic Spaniards and Lutheran Germans sacked Rome with great violence and thoroughness.

The sack was a traumatic event, politically and psychologically. Most of Italy came under Imperial influence, and the Florentine republic disappeared for ever, despite the efforts of Michelangelo and others. The optimism and vitality of the Renaissance waned so dramatically that it is usual to date the end of the High Renaissance to the year 1527. A timid conformist spirit became the norm in both life and the arts, reinforced by the growing vigour of the Catholic Counter-Reformation. A chastened papacy initiated a reforming movement that purified the Church and clarified its doctrine; but the Inquisition and the Index discouraged the old free speculation and careless 'paganism' of the Renaissance. It rapidly became apparent that a new age had begun – an aristocratic and devout age with its own sombre magnificence, though one that tempted all too many of its artists to indulge in artifice and empty rhetoric.

Michelangelo was deeply affected by these changes, which touched his inner life and so influenced his art; even external forces made their mark on his work, for the new piety found nudity distasteful in religious art and covered up the sexual parts of both saved and damned in the *Last Judgement*. However, the Counter-Reformation offered Michelangelo opportunities as splendid as ever. It strengthened the authority of the papacy, and men continued to identify the truth and greatness of the Catholic faith with the splendour of papal Rome. For the last thirty years of his life Michelangelo laboured to glorify Counter-Reformation Rome as he had done so much to glorify the Rome of the Renaissance.

Ascent to Fame

Michelangelo Buonarroti was born on 6 March 1475 in the village of Caprese, not far from the Tuscan city of Arezzo. His father, Lodovico di Lionardo di Buonarroti Simoni, came from what we should now call an upper-middle-class family that had fallen on hard times; Lodovico himself seems to have been a rather feckless man, too proud to work but always waiting, like Mr. Micawber in *David Copperfield*, for something to turn up. Meanwhile he was prepared to accept unpaid public office under the Florentine republic; and so it came about that Michelangelo, his second son, was born at Caprese, where Lodovico was serving the last few weeks of his term as Chief Magistrate.

The family then moved back to Florence, but Michelangelo was entrusted to a wet-nurse at nearby Settignano. Her husband worked as a quarryman, and in later years Michelangelo liked to say that he had imbibed a hammer and chisel along with his foster-mother's milk. It is of course possible that he continued to spend time with his foster-family during his boyhood, and actually did learn techniques of stone-carving there that later proved useful. Virtually nothing is known of the next few years except that his mother, after bearing three more sons in quick succession, died when he was six. He is said to have gone to school when he was ten and to have been in constant trouble because he neglected his studies in favour of artistic pursuits – which may have been true, but sounds suspiciously like the traditional account of The Genius As Schoolboy that graces every artist's biography. If Michelangelo's formal education really was a failure then he was effectively self-taught, for he wrote a beautiful hand, forceful letters

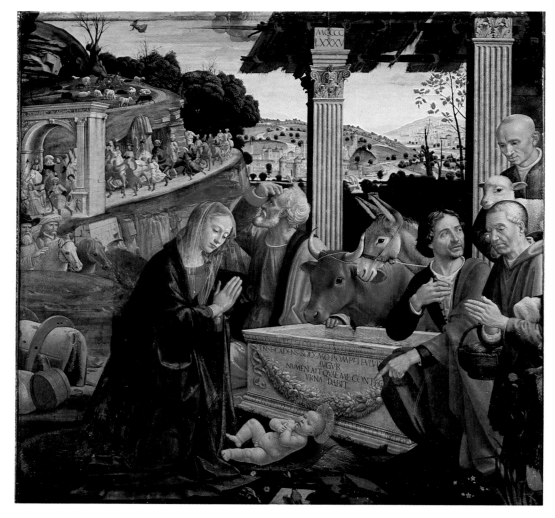

Domenico Ghirlandaio. *Adoration of the Shepherds*. 1485. Ghirlandaio was the leading Florentine fresco painter of his generation, and presumably taught the technique to his apprentice Michelangelo – who was, however, reluctant to acknowledge artistic debts to anybody. Santa Trinità, Florence.

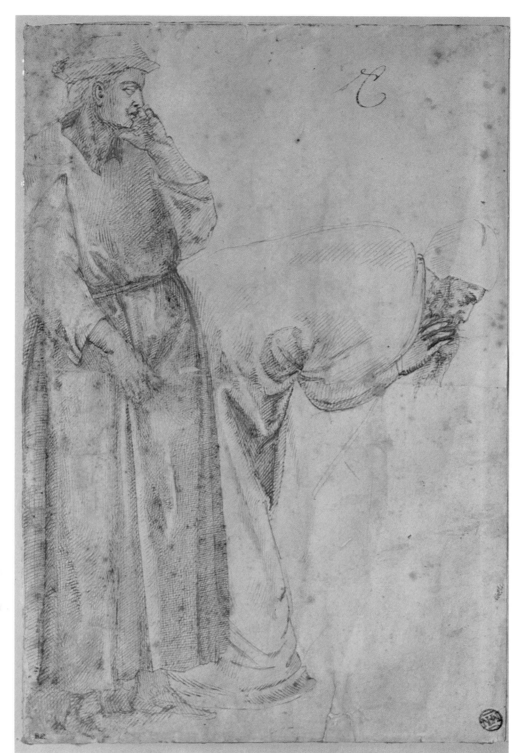

Drawing of two figures, after Giotto. *c.*1490. Here the young Michelangelo has copied two figures from a wall painting by Giotto in the Church of Santa Croce, Florence. Significantly, Giotto (*c.*1266–1337) was the first Italian painter to create a monumental and dramatic art of the sort that appealed to Michelangelo. Musée du Louvre, Paris.

and eloquent poems. What does seem likely, given the family's pretensions, is that Michelangelo had to overcome opposition and endure beatings before he was allowed to become an apprentice in the workshop of Domenico Ghirlandaio. The contract between Lodovico and Ghirlandaio is dated 1 April 1488, when Michelangelo had reached the relatively advanced age of thirteen.

Ghirlandaio was one of the leading painters of his generation, and his speciality was fresco, the technique used for decorating walls and ceilings. Since this was the very type of painting for which Michelangelo was later to become famous, it seems highly probable that he learned the rudiments of the technique from Ghirlandaio; Michelangelo himself was reticent about this and his other debts to older masters, for he came to accept and promote his own image as the 'divine' genius, too exalted to have been formed by any mere workshop. No doubt he gave more encouragement to the stories that described him as a prodigy who was effortlessly able to improve on his master's works. However, we know that he made careful drawings of works by Florentine painters he admired, notably Giotto and Masaccio; both, although living in different cen-

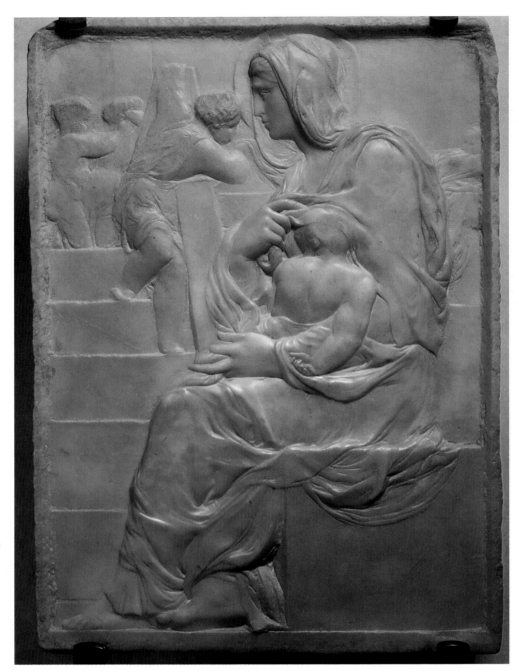

*The Madonna of the Steps. c.*1491. The earliest surviving sculpture by Michelangelo, a carving in low relief strongly influenced by the famous older master Donatello. Casa Buonarotti, Florence.

turies, had set out to create solid figures that looked as though they occupied space and were affected by gravity. In choosing these masters (and ignoring the more decorative works of later painters) Michelangelo already displayed a taste for monumentality which was to characterize his entire career.

Most of the legends about his precocity are rather standard fare, but there is one that has the idiosyncrasy of an authentic memory. Michelangelo is said to have copied a number of drawings he admired, and then to have 'aged' the paper by holding the drawings over smoke. In this fashion he created convincing fakes which he could substitute for the originals he coveted. He thus joined the illustrious company of art forgers, one of the few professions that has flourished with hardly a break since ancient times.

Within a year or so of joining Ghirlandaio's workshop, Michelangelo had been noticed by Lorenzo de' Medici and taken into his household. The traditional story is that Lorenzo, in his capacity as first citizen and cultural arbiter of Florence, became concerned about the lack of promising sculptors in the city by comparison with the large number of gifted painters. He persuaded Ghirlandaio to let him look over the efforts of some of his apprentices, and was immediately struck by Michelangelo's skill in an art with which the boy had had no previous acquaintance. He had copied an antique Roman head of an aged, wrinkled faun, altering it in some respects to suit his fancy. This included giving the faun an open mouth with a splendid set of teeth. When Lorenzo saw what Michelangelo had done, he jokingly remarked that in reality the old always have

some teeth missing. Taking the remark seriously, Michelangelo immediately knocked out one of the faun's teeth and drilled a hole in the gum to represent its socket – a characteristically impetuous gesture that makes one willing to believe an otherwise none-too-likely tale. Lorenzo was so impressed with this evidence of talent allied to fixed purpose that he sent for Lodovico Buonarroti and arranged that Michelangelo should leave Ghirlandaio and go to live at the Medici Palace.

Lorenzo's palace was the cultural headquarters of Florence and a treasure-house of *objets d'art*, so Michelangelo had unlimited opportunities to cultivate himself and learn his art. As well as a garden containing antique sarcophagi and other sculptures, Lorenzo possessed a famous collection of medals, coins and cameos – a display of styles and subjects in miniature that is easy to under-estimate until we remember that there were no photographic reproductions of large-scale masterpieces to help educate the eye of an apprentice artist. At Lorenzo's palace Michelangelo also met Bertoldo di Giovanni, a sculptor in his late sixties who had been the pupil of Donatello, the greatest sculptor of the 15th century. Bertoldo was in charge of the sculpture garden and may have given lessons on a more or less formal basis to Michelangelo and other protégés of Lorenzo. In this instance too, Michelangelo avoided any explicit acknowledge-ment of his debts; but whatever the precise nature of his relationship with Bertoldo, it is clear that at about this time he became aware of Donatello's achievements and was influenced by the heroic naturalism and emotional inten-sity of the older artist's figures.

Michelangelo's earliest surviving sculpture, the *Madonna of the Steps*, is a carving in low relief that owes a good deal to Donatello's work in the genre. But it is far less assured than the high-relief *Battle of the Centaurs*, an overcrowded, turbulent scene, which Michelangelo must have executed no more than a few months later. Here the subject is taken from Greek myth. The centaurs were half-men, half-horses who became involved in a brawl with a human people called the Lapiths; that seems to be what Michelangelo has represented on the relief, although the details are unclear and have given rise to a good deal of argument. The poet Poliziano, who was the tutor of Lorenzo's children, is said to have told Michelangelo the story, and to have encouraged him to translate it into sculpture. But, significantly, Michelangelo has so arranged the scene that the centaurs' horse-parts are hidden from view, and the battle appears to take place between two groups of naked men. In other words, he had already hit upon the main subject of his life's work, one with which he would prove capable of

*The Battle of the Centaurs. c.*1491. A turbulent work in high relief. Though nominally a battle between the Lapiths and the half-horse, half-human Centaurs, the action is skilfully arranged to look like a struggle between two groups of naked men. Casa Buonarotti, Florence.

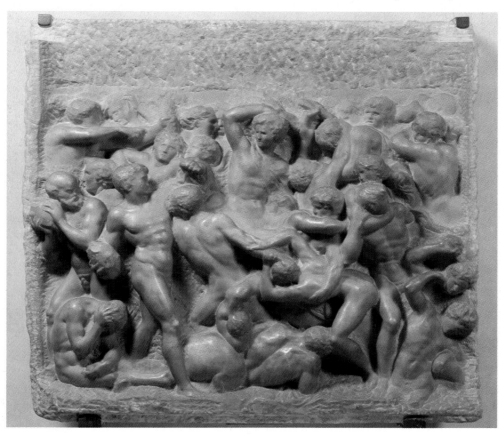

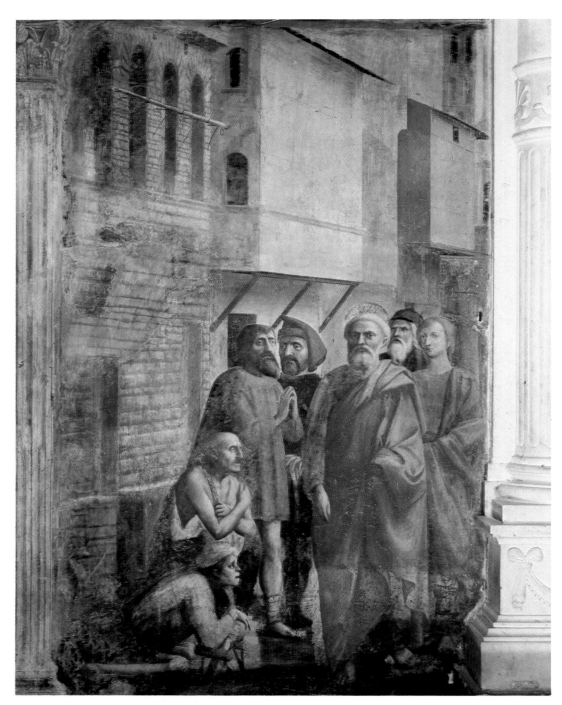

expressing an astonishing range of emotions – the nude male. Together, the *Battle of the Centaurs* and the *Madonna of the Steps*, the latter with its flowing draperies, Christian subject and intimations of sorrow, foreshadow Michelangelo's mature preoccupations. The co-existence of Classical and Christian was not unusual in itself, but in Lorenzo's circle there was a strong tendency to identify the two by collating supposed correspondences and 'anticipations' that satisfactorily classicized Christianity and Christianized the classics; the technique had been used since the Middle Ages on the Old Testament stories, so the neoplatonic philosophy of Lorenzo culminated in an impressive if artificial synthesis of all the sources of European culture. The mingling of these elements in Michelangelo's work – particularly on the Sistine Chapel ceiling – reflects his youthful immersion in neoplatonism. This grand cultural synthesis, implicity expansive and optimistic, was to become less persuasive as Italy plunged into the 16th-century crisis, but Michelangelo had abandoned it for a more pessimistic piety even before it came to be seen as vaguely heretical.

Neoplatonism held that outward beauty was a manifestation or symbol of beauty within, a doctrine that must have been congenial to an artist like Michelangelo whose passion was to create human beings of great physical splendour. Ironically, Michelangelo's own outward beauty was spoiled by one of his fellow-students, a sculptor called Pietro Torrigiano. According to his own account,

Torrigiano was incensed by Michelangelo's habit of sneering at everybody else's drawings when he and others were working in the Church of the Carmine, which houses Masaccio's paintings; however, according to Michelangelo's biographer, Torrigiano was simply jealous. Either or both may well be true. The outcome was that Torrigiano punched Michelangelo very hard and broke his nose, giving him the rather pugilistic visage that his contemporaries faithfully recorded in engravings and paintings, and on busts and medals. Although it was he who inflicted the injury, Torrigiano continued to bear a grudge. Many years afterwards he described the incident to the sculptor Benvenuto Cellini, noting spitefully that 'that fellow will carry my signature until he dies'.

TROUBLED TIMES

Michelangelo's years as a student-guest at the Medici Palace were probably the most carefree of his entire life. They came to an abrupt end with Lorenzo's death in 1492, after which things were never quite the same again, either for Michelangelo or for Florence. The Florentines had become so habituated to Medici leadership that they asked Lorenzo's eldest son, Piero, to assume his father's role, despite the widespread opinion that Piero was arrogant and inept; even Lorenzo had noted sadly in his private journal that Piero was a fool. Unluckily for Piero, there was to be no tranquil future in which a fool might hope to survive as the head of state.

On Lorenzo's death, Michelangelo moved out of the Medici Palace and back into his father's house. About this time he began to study anatomy by dissecting corpses at the hospital run by the monks of San Spirito. Influenced by the Renaissance spirit of enquiry, the Church had in practice relaxed its ban on dissection, and a number of artists before Michelangelo's time had taken advantage of the situation to investigate the structure of the bodies they attempted to portray; Michelangelo's older contemporary, Leonardo da Vinci, became such a dedicated anatomist that he would have ranked as a pioneer of the subject but for his characteristic failure to publish his findings. It is, of course, no co-incidence that Leonardo and Michelangelo were great masters of the High Renaissance style, whose monumental figures have a physical presence that can be sensed even when they are elaborately dressed. The High Renaissance artist could convey the musculature beneath clothing because he had studied the muscles beneath the skin.

Lacking employment, Michelangelo bought a block of marble on his own account and carved a figure from it without having received a commission to do so – an unusual action at that time, especially for a young, little-known sculptor. The figure was an over-life-size *Hercules*, now unfortunately lost, which must have made obvious the heroic scale of Michelangelo's ambitions. He managed to sell the statue to the patrician Strozzi family. By contrast, Piero de' Medici gave him only one – fanciful – commission. After a heavy fall of snow in January 1494 he sent for the sculptor and asked him to create . . . a snowman. It is an enlightening commentary on the relationship between artists and patrons that Piero should have made such a request, and that Michelangelo should have dutifully carried it out. His snowman must have been an impressively ingenious object, for Piero was so delighted with it that he installed Michelangelo in the palace again.

Donatello. *The Healing of the Wrathful Son. c.*1443–1450. A gilt bronze relief for the high altar by the greatest Florentine sculptor before Michelangelo. San Antonio, Padua.

But that was all; perhaps Piero became too concerned about his political difficulties to think of art. Florence was in the grip of economic recession and religious hysteria. A Dominican monk, Fra Girolamo Savonarola, was preaching to huge audiences who thrilled at his denunciations of their sinfulness and the corruption of the Church, and shivered at his prediction that a scourge of God was about to descend upon Italy. This eruption of an apocalyptic Christianity shook intellectuals and artists as well as the masses, revealing the shallow emotional roots of Neoplatonic philosophy; one of its most distinguished adherents, Lorenzo's friend Pico della Mirandola, was 'converted' to Savonarolan fundamentalism. And Michelangelo fled – whether from the wrath to come, as predicted by Savonarola, or from a rational appraisal of the internal and external dangers of life in Florence, we do not know. At any rate the 'Scourge of God' appeared soon afterwards in the shape of the French King Charles VIII and his army, which signalled the beginning of a new age of war and foreign interventions that humiliated and demoralized Italy. The more immediate effect, after Piero had vacillated disastrously between defiance and submission, was a *coup d'état* in which the Medici were expelled and Florentine institutions remodelled. Michelangelo may well have felt that he was better employed elsewhere.

His flight took him first to Venice, the ancient mercantile republic on the Adriatic, famous for its canals and lagoons. But he can have found little encouragement there, for he soon returned much closer to home, to the city of Bologna. He was having difficulty with the Bolognese customs when the wealthy connoisseur Gianfrancesco Aldovrandi rescued him. He spent the next year as

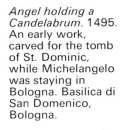

Angel holding a Candelabrum. 1495. An early work, carved for the tomb of St. Dominic, while Michelangelo was staying in Bologna. Basilica di San Domenico, Bologna.

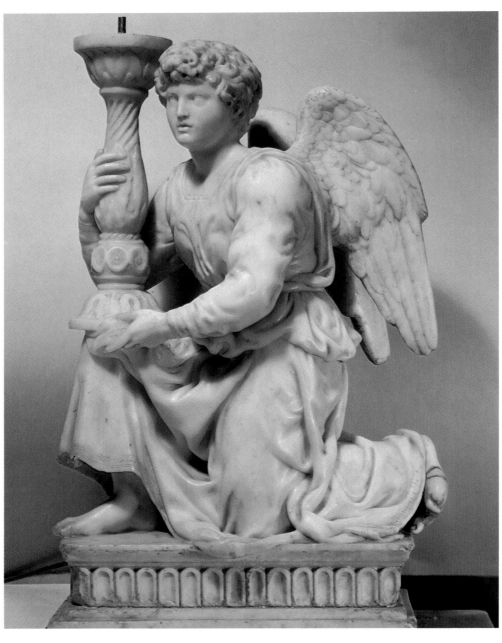

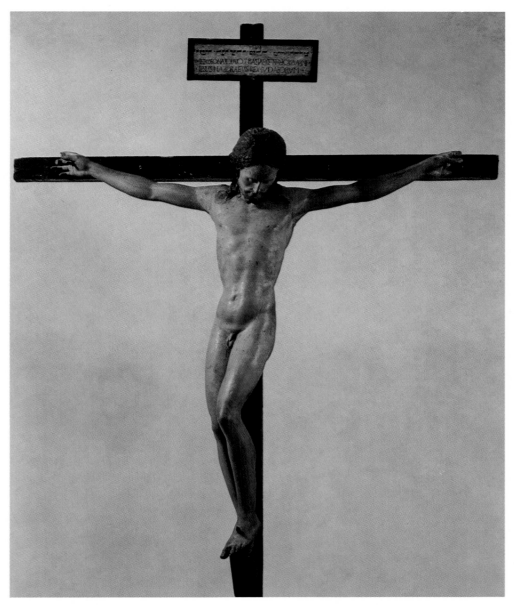

Crucifixion. 1492–93. This wooden crucifix is said to have been carved by Michelangelo as a young man. Casa Buonarotti, Florence.

a guest at Aldovrandi's house, though all we know of their relations is that Michelangelo read his host to sleep every night from Dante, Petrarch and Boccaccio; the prestige of all things Florentine was such that Aldovrandi went into ecstasies over Michelangelo's Tuscan accent. He was probably responsible for finding Michelangelo some work on the tomb of St. Dominic, a major Bolognese project that had been left unfinished on the death of the sculptor Niccolò dell' Arca. Michelangelo carved three small figures for the tomb, notably an angel holding a candelabrum that invites a direct comparison with one of dell' Arca's angels; even on this very small scale, Michelangelo's figure is more weighty, more ambitiously and elaborately draped, and (so to speak) takes itself more seriously than dell' Arca's charming but slighter and stiffer figure. The two angels encapsulate many of the differences between the Quattrocento (15th-century) and High Renaissance styles. Even so, Michelangelo's work in Bologna represents an adaptation of his style to that of the almost-finished tomb; he never again carved or painted an angel with wings, characteristically relying on his ability to express everything – function as well as feeling – through the medium of the human body alone.

At some time in the winter of 1495–6 he returned to Florence. The city's revised constitution was far more democratic than in Lorenzo de' Medici's time, but Savonarola's influence was now all-pervasive; his determination to stamp out sin and turn Florence into a New Jerusalem, covertly opposed by the Medicean-aristocratic party, created an atmosphere of fanaticism and tension resembling that of the Terror during the French Revolution. Understandably, Michelangelo did not stay long; his departures from Florence during this period contradict the once-common notion that he was a follower of Savonarola (which is not to say that the Dominican's frenzy did not raise up a host of religious

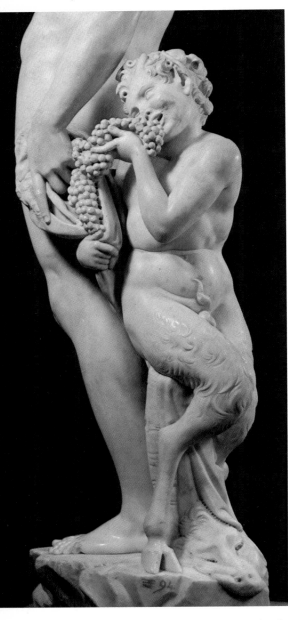

Below: Detail of the satyr from *Bacchus*. *c.*1497. Nibbling Bacchus' grapes while the god is too drunk to notice, the satyr also performs a function – he serves to buttress the main figure. Muzeo Nazionale del Bargello, Florence.

Far right: *Bacchus*. *c.*1497. An appropriately tipsy-looking version of the god of wine. It was the first work executed by Michelangelo in Rome. Muzeo Nazionale del Bargello, Florence.

terrors in the artist's mind). Before he went, he carved a *St. John the Baptist* and a *Sleeping Cupid*, both now lost. The *St. John* was done for a member of the cadet branch of the Medici family, Lorenzo di Pierfrancesco, who in these difficult times was prudent enough to call himself Lorenzo Popolano, 'Lorenzo of the People'. It was he who made a suggestion that had singularly happy consequences for Michelangelo. Seeing the *Sleeping Cupid*, he remarked that Michelangelo would get far more money for it if he could pass it off as an antique, newly recovered from the earth. So Michelangelo embarked on his second episode of faking, after which Lorenzo sent the (presumably) worn and stained *Cupid* to an unscrupulous dealer in Rome. The dealer paid Michelangelo a miserable thirty ducats for it, but did indeed sell it as an antique for 200 ducats. Later on, the purchaser, Cardinal Raffaele Riario, discovered the deception and successfully demanded his money back. The incident proves two things: that sophisticated Renaissance collectors, like their modern counterparts, worried more about the origin of a work of art than about its inherent qualities; and that the Renaissance mania for antiquity was so powerful that *all* Greek and Roman works of art were considered superior to contemporary productions.

For Michelangelo the consequence of this escapade was that it brought him into contact with Cardinal Riario, who evidently appreciated his talent sufficiently to invite him to Rome.

THE YOUNG MASTER

In Rome, Michelangelo could hope for rich commissions of a sort unlikely in a puritanical Florence. He could also hope for opportunities to study the unrivalled collections of antiquities; he was as passionately interested as his contemporaries in the Classical past, and determined to equal and ultimately surpass its finest works. Riario, with whom Michelangelo lived for a year, possessed one such collection. He was one of those princes of the Church whom Savonarola denounced so vigorously – a connoisseur and a prince indeed, whose grand Palazzo della Cancelleria (still one of the notable sights of Rome) had just been built, paid for with the 60,000 ducats Riario, a nephew of Pope Sixtus IV, had won in a single night's gambling . . . with another pope's nephew. If the young Michelangelo felt any Savonarolesque revulsion at the worldly splendour in which his patron lived, he must have kept it to himself.

The first of Michelangelo's Roman works that we know about was not done for Riario but for his neighbour Jacopo Galli, another wealthy Roman with a sculpture garden full of antique fragments. The *Bacchus* was made for the sculpture garden and seems to have harmonized admirably with its surroundings. Yet Michelangelo's version of the antique is, like all such revivalistic pieces (and copies and fakes), subtly different in mood and treatment from the works that inspired it. The statue represents the god of wine, swivel-eyed and open mouthed, lurching under the influence of drink; despite the grapes and vine-leaves strewn in his hair, he is not a particularly merry figure. This element is supplied by the naughty little goat-legged satyr who slyly nibbles Bacchus' grapes; he supports the drunken god in a technical as well as an imaginative sense, acting as the buttress necessary to hold up a single marble figure of such a size. The *Bacchus* was Michelangelo's first major work, a tangibly boned and full-fleshed creation whose like had not been seen since antiquity; its revolutionary quality can only be appreciated now by shutting all later sculptures out of the mind and comparing it with the achievements of even the greatest of 15th-century masters.

Michelangelo's next commission was for a still more ambitious work – a *Pietà*, a representation of the grieving Mary cradling the crucified Jesus in her lap. His new patron was a French cardinal, Jean Villiers, who wished to leave a fitting memorial to himself in the chapel of the kings of France in St. Peter's. Jacopo Galli probably obtained the commission for Michelangelo; in the contract, dated 27 August 1498, he guaranteed that Michelangelo would deliver the sculpture within a year, and that it would be 'the most beautiful work in marble that Rome can boast of, and one that no master of our time will be able to better' – a rhetorical flourish that proved to be nothing less than the truth.

The *pietà* was not yet a common subject in Italian art, having originated in northern Europe, and it proved extraordinarily difficult to treat satisfactorily – difficult, that is, from a realistic as opposed to a northern expressionistic standpoint (in which distortions might be introduced to heighten the emotional impact). Michelangelo was magnificently, unbelievably successful; even now,

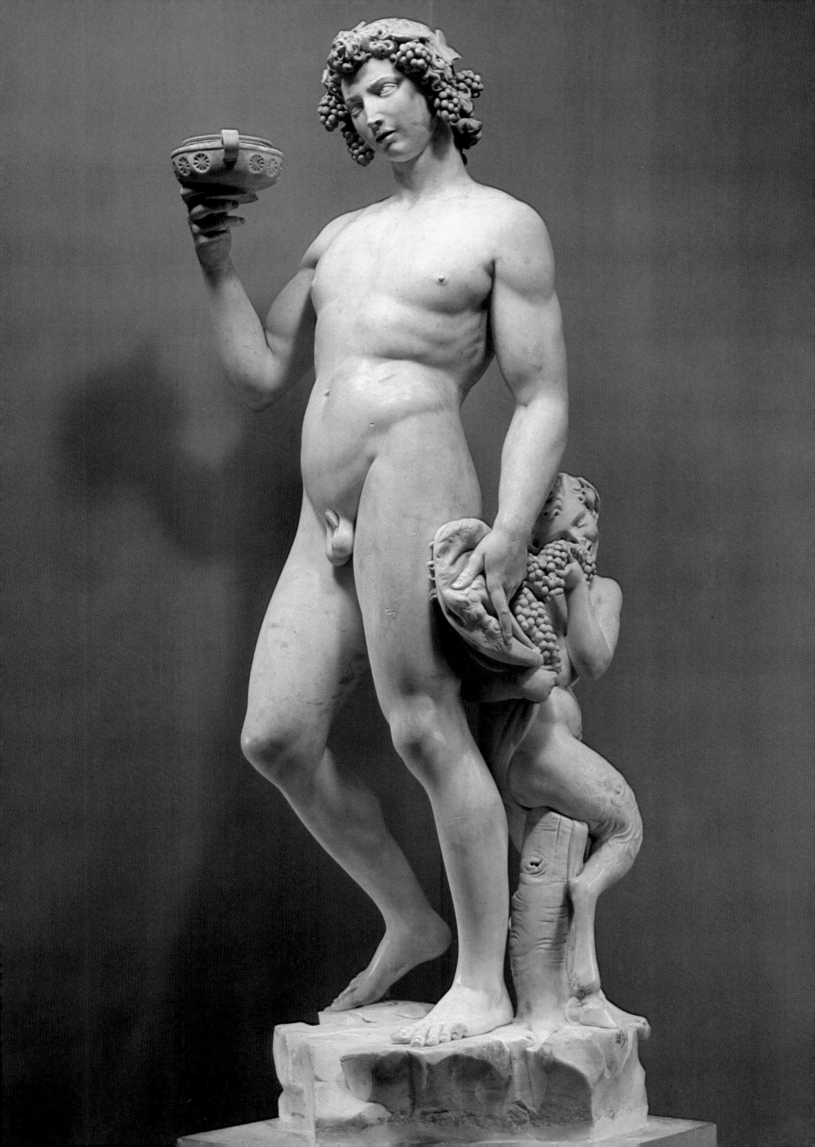

at a first sight of the *Pietà* (from a distance, unfortunately, and through unbreakable glass, since the group was badly damaged in an act of crazy vandalism), the viewer is conscious of an utter astonishment before he feels anything else. The sculpture is completely convincing in a realistic sense, but its achieved quality is actually made possible by two pieces of illusion. The Virgin is much larger than her son – if she were upright she would stand about 7 feet (213 cm) tall – and her garments are impossibly voluminous, making a broad and deep resting-place of her lap, and then pouring away below it to spread out over the surrounding rocks. Through the combination of height and mass that these tricks made possible, Michelangelo transformed this most awkward of poses into a tightly contained pyramid shape (pleasing in itself and, in the event, the most admired formal device of the entire High Renaissance). He made of the *Pietà* a work of supreme virtuosity, seizing the opportunity of a really important commission to bring off a *tour de force* that might transport him at a leap to the Temple of

Below: *Pietà*. 1498–1500. The *pietà*, representing Mary cradling the dead Christ on her lap, was more common in Northern than Italian art; but here Michelangelo solved the compositional problems with superb assurance. St. Peter's, Rome.

Right: Detail of Mary's head and shoulders from the *Pietà*. 1498–1500. St. Peter's, Rome.

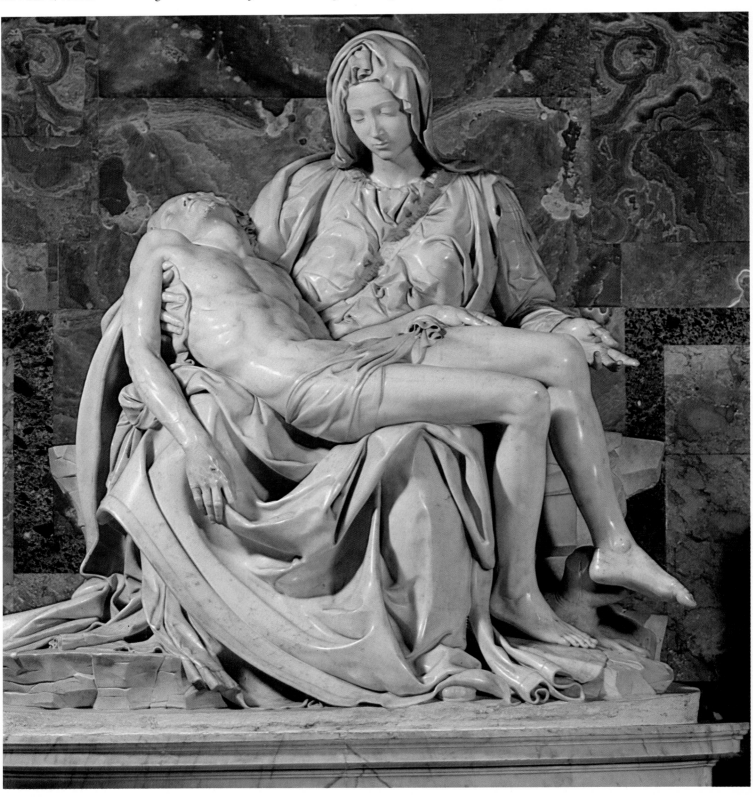

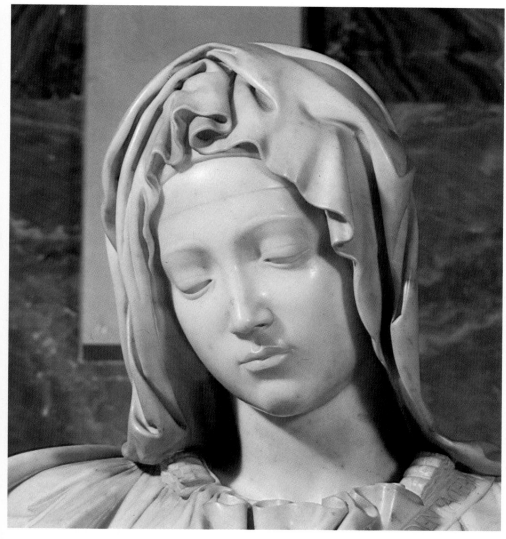

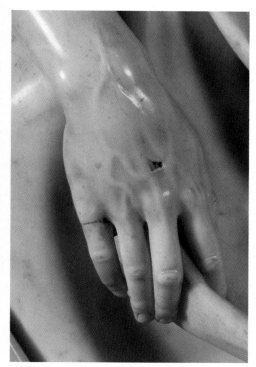

Below: Detail of Christ's hand from the *Pietà*. 1498–1500. St. Peter's, Rome.

Fame. The marble is cut and polished to a higher finish than any of his other works; the drapery is carved with an agitated display of folds and creases and rucks that he never again felt to be necessary (in some places it is thin enough to be translucent); and both the Virgin and the dead Christ are touchingly young and of an ecstatic, unblemished beauty. Though no one would deny that the *Pietà* is a masterpiece, its staggering virtuosity is more apparent to a modern eye than the religious emotion it should embody; it is, finally, brilliant rather than moving; and it can hardly be a matter of chance that Michelangelo's subsequent development was away from this kind of brilliance and towards simplification of detail and an expressive force.

But if his object was fame, he achieved it. Renaissance Italians relished virtuosity and marvelled at the *Pietà*. But even at the time there were carpers who asked why Mary looked younger than her son. In his old age Michelangelo was still troubled enough by this criticism to embark on a long and rather tortuous explanation; the burden of it was that chaste women keep their freshness longer than the unchaste, and that Mary's particular purity would have accentuated this effect. A more likely explanation is simply that Michelangelo wanted the figures on this showpiece of his art to be beautiful, confident that symbolism, allegory or Neoplatonism would provide the necessary pretext.

FLORENTINE TRIUMPHS

The *Pietà* was probably finished at some time in 1500. Michelangelo's next work may have been a panel painting, *The Entombment*, showing the body of Jesus being carried to its tomb. It is a curious, unsatisfactory composition that seems to have been worked on by a second artist and nonetheless remains unfinished. So little is known about its history that it has been variously dated between 1495 and 1505 – before Michelangelo's first visit to Rome or after his first Florentine masterpieces.

He returned to Florence in May 1501, probably to work on a commission in nearby Siena. Cardinal Francesco Piccolomini ordered fifteen marble figures

Above: Detail of Christ's feet from the *Pietà*. 1498–1500. St. Peter's, Rome.

for his altar in the cathedral, but Michelangelo either lost interest in the project or never managed to find the time for it, and only four figures were ever delivered.

Florence was a less turbulent place than the Savonarolan city he had left five years before. The Medici were still in exile, but Savonarola was dead. His power had reached its peak in 1497 and 1498 with 'bonfires of vanities' which included such sinful items as cards, cosmetics, jewellery and paintings. Then, as his denunciation of papal vices became more and more extreme, he was excommunicated, the mob turned against him, and in May 1498 he was tortured, hanged and burned as a heretic in the main square where the 'vanities' had perished shortly before. The republican constitution was now in process of modification, leading to the establishment of a chief executive, the Gonfaloniere, elected for life. As the new Gonfaloniere, Pietro Soderini, was a friend of Michelangelo's, the sculptor must have felt quite comfortable in the new Florence – all the more so since, within three months of his arrival, he carried off the most ambitious commission the city had to offer.

Below: Donatello. *David. c.*1434. A famous bronze figure of the Biblical hero who slew Goliath, quite different in feeling from Michelangelo's colossus. Muzeo Nazionale del Bargello, Florence.

Right: Detail of the head of *David.* 1501–4. Michelangelo's work was largely inspired by what he knew of Greek and Roman statuary, but his David is 'modern' in the psychological tension apparent in his face. Accademia, Florence.

Far right: *David.* 1501–4. A colossal marble figure of the youthful David, carrying over one shoulder the sling with which he will slay the Philistine Goliath. Accademia, Florence.

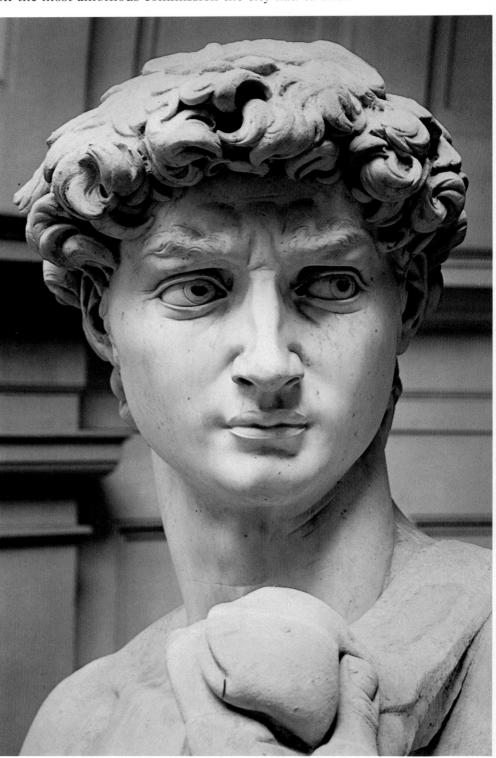

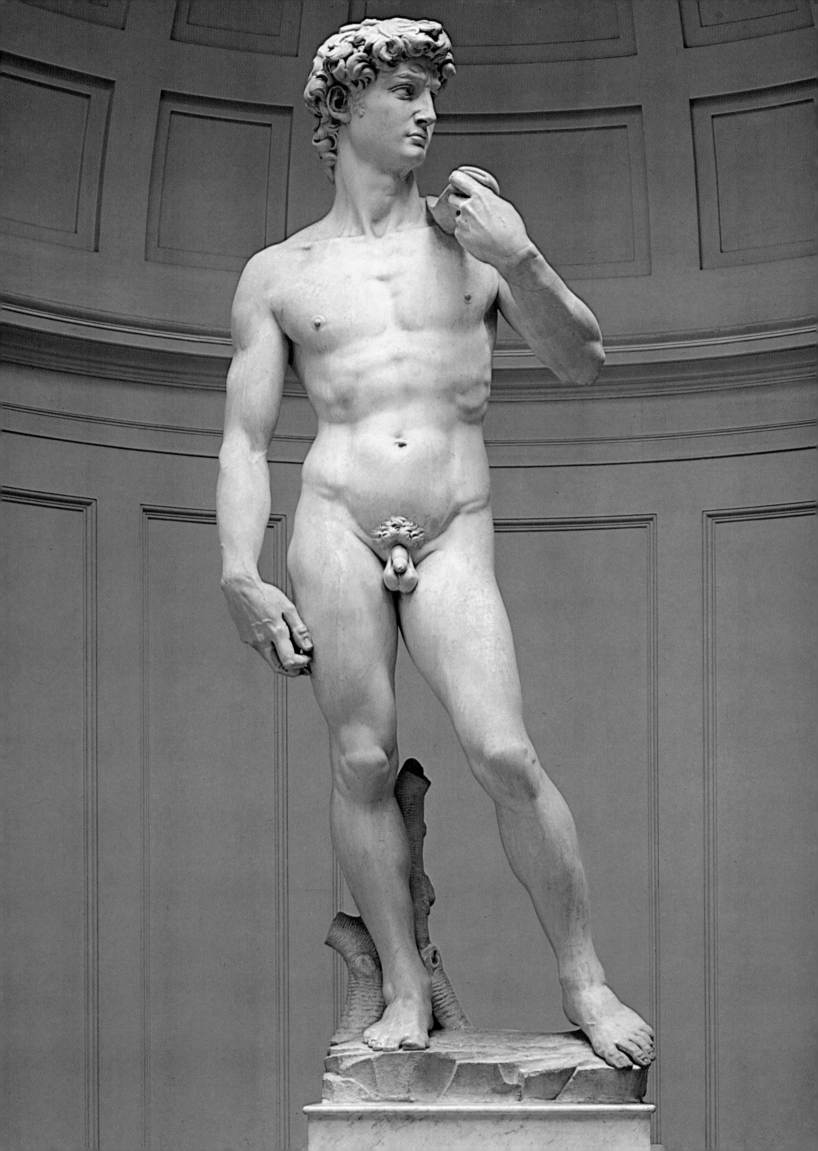

An 18-foot (549-cm) high block of marble, nicknamed 'The Giant', had been lying in a yard near Florence Cathedral since the 1460s. It had originally been intended for the cathedral, but after abortive plans, frustrating delays and even a false start by a sculptor called Agostino di Duccio, the project had been abandoned. 'The Giant' must have been one of the sights (or eyesores) of Florence throughout Michelangelo's boyhood and youth, and must have made his fingers itch; to work on such a scale was the dream of every High Renaissance artist. In 1501, when the new republican order began to think of showing its confidence in the future by commissioning a colossal statue, the first names put forward were those of Leonardo da Vinci and an able pupil of Bertoldo's, Andrea Sansovino. It may have been rumours about this, rather than the Sienese sculptures, that brought Michelangelo back to Florence in 1501. At any rate he won the commission within three months of his arrival and, with two years' wages guaranteed, set to work behind a structure of wooden boards and trestles that hid the proceedings from prying eyes. The statue, it was agreed,

*The Pitti Tondo.
c.*1505. A carving of
the Madonna and
Child; its name
derives from its
sometime owners.
Muzeo Nazionale del
Bargello, Florence.

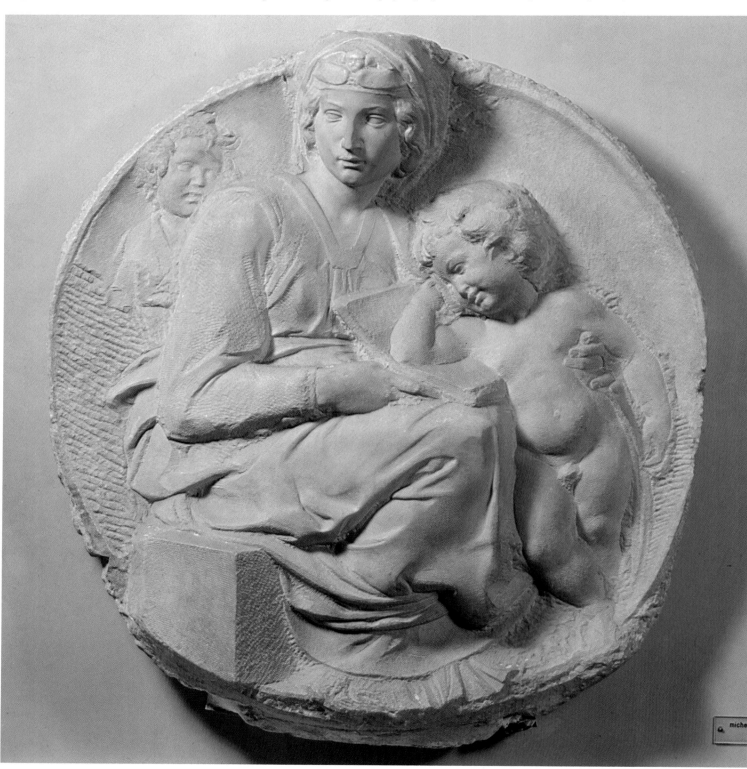

should be of David, the Biblical hero who slew the Philistine giant Goliath with a stone from his sling, and later became king of Israel after the death of Saul. The Florentines seem to have identified with the giant-slayer (conscious perhaps that their city was at once small and great) and the bronze *Davids* of Donatello and Verrocchio are arguably the finest Florentine statues of the 15th century.

Michelangelo's *David*, however, is no defiant boy – who would, after all, have made a rather strange colossus – but a superb creature in the full splendour of young manhood. The Florentines recognized at once that this was one of the master-works of its age. It embodied everything that 15th-century sculptors had been trying to achieve in the way of truth to nature, and went beyond them to express a passionate sense of inner life and idealism. It surpassed the known works of antiquity, which was in itself the most thrilling of events for Renaissance man, conditioned as he was to think of the Italian achievement in terms of rebirth rather than originality or advance; and it introduced into

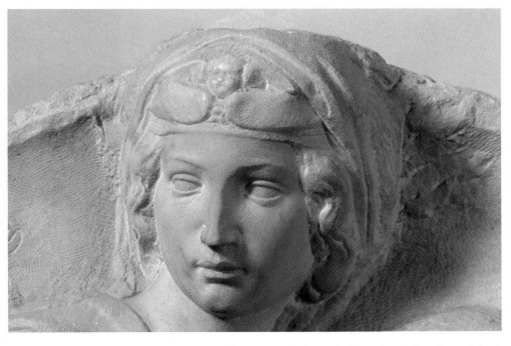

sculpture psychological tension and the anxieties of thought. The *David* is a glorification of male beauty, at one and the same time real and ideal, shown in a classically relaxed position with the weight on one leg and the other slightly bent, thus combining stillness with the promise of movement. Yet this relaxation is contradicted by the implicit force of the veined and enlarged right hand, and the straining head and anxious features. If they represent David's self-preparation for the battle, this is shown as a mental and moral event, not a physical one. Here, for the first time, Michelangelo performed his characteristic feat of making physical splendour the vehicle of emotions and ideas.

The colossus was finished by early 1504, and a committee was appointed to advise on a site. The membership of the committee reads like a roll-call of contemporary genius (Leonardo da Vinci was included, along with Andrea della Robbia, Botticelli, Filippino Lippi, Perugino, Sangallo and others), but the final choice seems to have been Michelangelo's. Forty men transported *David* on fourteen rollers into the Piazza della Signoria (the main square), an operation requiring such care that it took four days; then the statue was erected on the left-hand side of the entrance to the Signoria (the town hall), displacing Donatello's bronze *Judith and Holofernes*, which had Medici associations. A plinth was made, and the *David* was officially put on show on 8 September 1504.

Michelangelo's speed in executing the *David* is the more impressive because he must have worked simultaneously on a number of other projects. As well as the four figures for the Piccolomini altar, he made a bronze David, now lost, for a French nobleman, carved the *Bruges Madonna* for a Flemish merchant, and executed three Madonnas, one a painting and the other two carved in relief, all circular in shape (*tondi*). He also agreed to carve twelve apostles for Florence Cathedral, a project whose outcome was even less substantial than that of the Piccolomini commisssion. All this work makes an impressive but also an

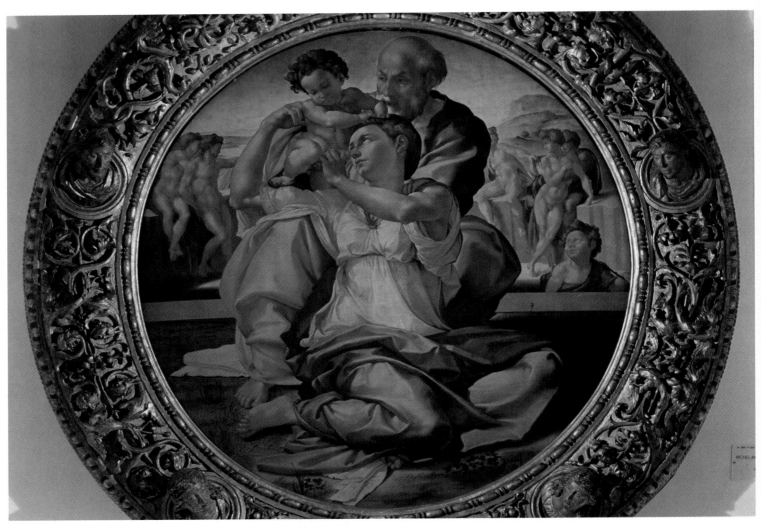

*The Doni Tondo.
c.*1505. A painting
of the Holy family.
It is very much a
sculptor's work,
monumental and
hard-edged; its
brilliant metallic
colour derives from
the medium, which
is not oils but
tempera (pigments
mixed with egg-
yolk). Galleria degli
Uffizi, Florence.

ominous record. Michelangelo had, it seems, acquired the habit of accepting every task that was offered, believing in typical Renaissance fashion that a combination of will power and genius would enable him to accomplish anything he attempted. Even at this early stage in his career the belief was proving fallacious; later on, as he committed himself to exigent popes and dukes, the habit was to cause him torment and frustration.

Of the works mentioned above, the *Doni Tondo* has a special interest as the only finished painting by Michelangelo that was not done directly on to a wall or ceiling. Like the unfinished *Entombment*, it was painted in the tempera technique, using pigments mixed with egg-yolk; in the pure form of the technique, the pigments were usually thinned with water and then applied to the prepared surface of the wooden panel, but Michelangelo's practice involved mixing in a certain amount of oil. Tempera colours were of a rather glossy brilliance, hard and opaque, by contrast with the oil-painting technique that was becoming increasingly popular. Oil colours could be used to build up a painting on canvas in thin layers, making it possible to achieve subtle gradations of tone and atmospheric effects; Leonardo da Vinci was probably working at this very time on the *Mona Lisa*, in which the technique was exploited more thoroughly than ever before. The quick-drying tempera colours gave far less scope for atmospheric effects, or even for corrections or second thoughts; hence they were to be superseded by oils, which became the medium for the most ambitious paintings for the next few hundred years. Michelangelo's choice of tempera is more likely to have been an expression of taste than of conservatism. The *Doni Tondo* is very much a sculptor's work. The main figures are grouped tightly together, as if cut from a single block of stone; all the edges are sharply defined, and the metallic light falls on solid flesh and stiff draperies that gleam as though they have been highly polished. The result is a painting that fascinates but is too lacking in warmth to be entirely successful – or perhaps one should say 'not as successful as we expect anything from Michelangelo to be'. This impression is reinforced by the conscious virtuosity of the design, with the kneeling Madonna reaching above and behind her to take the infant Jesus from Joseph. The

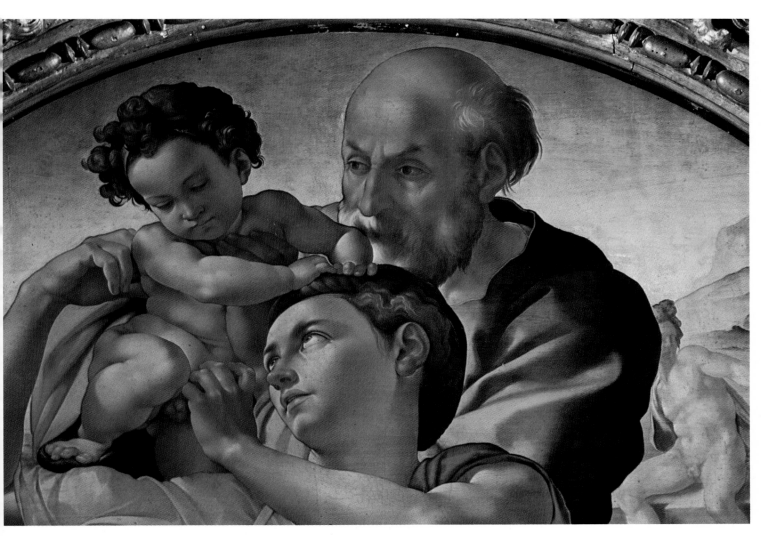

Detail of the heads of the Holy Family in *The Doni Tondo*. c.1505. Galleria degli Uffizi, Florence.

group is further 'put on display' by the horizontal band that fences it off from the young John the Baptist and the vaguely Classical nudes lounging in the background. One plausible explanation for such an arrangement is that the figures behind the strip represent the old (that is, pre-Christian) dispensation. This would account for the inclusion of the nudes, representing Classical antiquity, though an Old Testament scene might have been more appropriate; one suspects that here, as with the youthful Virgin of the *Pietà*, the precise religious-symbolic 'meaning' – which was certainly regarded as an important part of any work – was manipulated after the event to fit the creations of this worshipper of ideal beauty.

In 1504 Michelangelo was brought into more direct competition with Leonardo da Vinci. Leonardo was the only artist in Italy who could rival Michelangelo's achievement, a situation made all the more piquant by the fact that both were Florentines. Leonardo was twenty-three years older than Michelangelo, and had spent seventeen years at Milan, where he had created an equestrian statue of Francesco Sforza and a *Last Supper* fresco that made him the most famous artist of his generation. Unfortunately we cannot compare these with equivalent works by Michelangelo, since the statue was destroyed after the French invasion of Milan and the *Last Supper* has been in a ruinous state for centuries. Few Florentines can have seen them either, but when Leonardo returned to the city in 1500 he created an almost immediate sensation by exhibiting a superb cartoon showing the Virgin and Child with St. Anne and St. John the Baptist. (A cartoon is a full-scale drawing of a painting that an artist intends to execute, and is usually 'transferred' by one means or another directly onto the canvas or wall before painting begins.) So in 1501, when Michelangelo returned to his native city after carving the *Pietà*, he may have found himself overshadowed by the older artist. Over the next few years, while Michelangelo was occupied with the *David*, Leonardo took service as a military engineer under the tyrant Cesare Borgia; then he came back to Florence, and in October 1503 was commissioned to paint a huge fresco on a wall in the Grand Council Chamber of the Palazzo della Signoria. Clearly the handing out of such com-

missions as this one and the *David* were symptoms of a renewed confidence and optimism after the gloom and hysteria of the Savonarolan period.

Soon after Michelangelo finished *David*, the Signoria (the ruling body of Florence) asked him to paint a fresco on one of the other walls of the Grand Council Chamber. It is easy to imagine the malicious pleasure the Florentines took in this deliberate matching of the city's two supreme artists – and especially since they notoriously disliked each other. Most of the aggression appears to have been on Michelangelo's side (on at least one occasion he even shouted sarcasms after Leonardo in the street), but they seem to have been incompatible in almost every respect. Leonardo was tall, handsome and fastidious, with graceful manners and considerable charm behind which he hid a rather withdrawn personality; Michelangelo was plainer and broader and blunter, more obviously secretive and suspicious, and taciturn or ironic in speech unless provoked into an outburst of rage. And the opposition went deeper: Leonardo was an empiricist, addicted to collecting facts and indifferent to the grand generalities of philosophy and theology; whereas Michelangelo was steeped in the Christian-Classical outlook of neoplatonism, and grew increasingly obsessed with religious questions as he grew older. The main characteristics the two men had in common were a superhuman capacity for work and a marked tendency to leave their projects uncompleted. Even this last characteristic, though partly caused by a shared perfectionism, seems to have sprung from different psychological roots – Leonardo's from an almost neurotic reluctance to finish (and deliver a painting or publish a book), Michelangelo's from an omnivorous ambition that impelled him to undertake impossible tasks, and even redefine them to enlarge their scope.

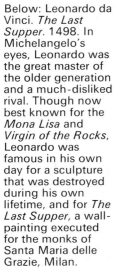

Below: Leonardo da Vinci. *The Last Supper*. 1498. In Michelangelo's eyes, Leonardo was the great master of the older generation and a much-disliked rival. Though now best known for the *Mona Lisa* and *Virgin of the Rocks*, Leonardo was famous in his own day for a sculpture that was destroyed during his own lifetime, and for *The Last Supper*, a wall-painting executed for the monks of Santa Maria delle Grazie, Milan.

Right: Francesco da Sangallo. Copy of Michelangelo's *Battle of Cascina*. A near-contemporary copy of Michelangelo's famous cartoon (full-size preparatory drawing) for a fresco that was never executed. The cartoon influenced an entire generation of Italian artists and made the male nude the chief subject of painting and sculpture. The original cartoon was cut up, distributed among Michelangelo's admirers, and eventually fell to pieces. Collection of the Earl of Leicester, Holkham Hall, Norfolk.

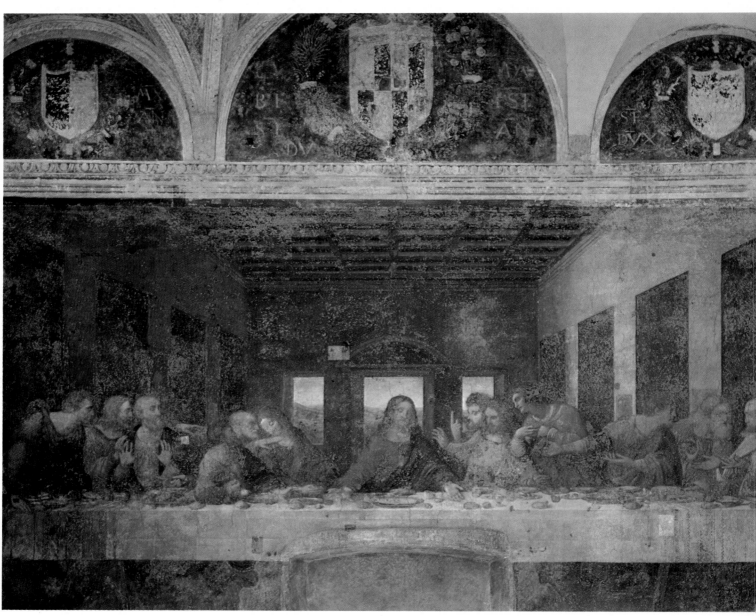

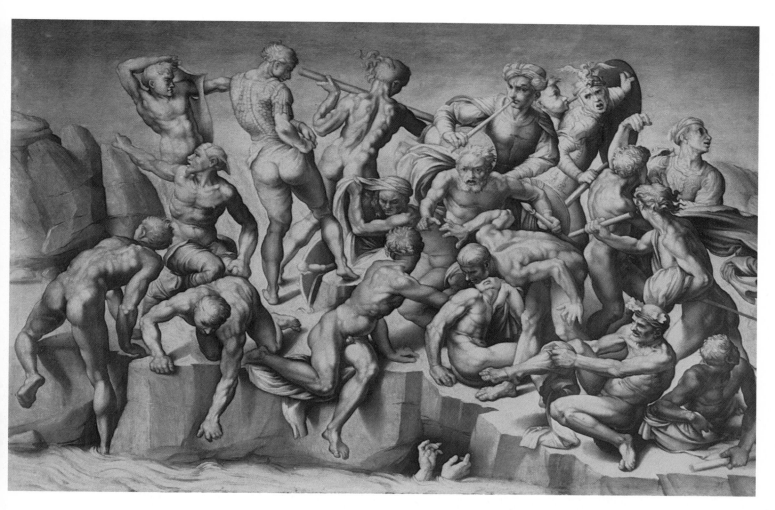

In retrospect, then, the battle of the titans to which the Florentines looked forward was not likely to reach a satisfactory conclusion, and in fact it proved a fiasco. Leonardo, set to re-create the *Battle of Anghiari*, completed the cartoon and got as far as painting the central incident. Then, having used an oil medium in order to achieve the kind of effects that were normally only possible in easel painting, he tried to dry out the work by introducing burning braziers into the hall. As a result, the upper part of the picture darkened and the lower part began to run. Shortly afterwards Leonardo was conveniently summoned to Milan, and despite angry remonstrations by the Signoria he did no more work on the *Battle of Anghiari*. Michelangelo did no better with his commission, the *Battle of Cascina*, though in this instance the fault was not his. He completed a cartoon of the *Battle* – that is, a wall-sized drawing made up of many sheets of paper; records have survived of the payments made by the authorities for the paper itself and for the job of sticking them together. Then he was summoned to Rome by the new pope, Julius II, who set him tasks of such vast scope that there was never again any question of his painting a fresco in the Grand Council Chamber.

As a republican propaganda exercise the 'Battle' commissions failed utterly. But the quality of the cartoons by Michelangelo and Leonardo was such that artists came from all over Italy to study them. One such was the young Raphael of Urbino, whose reputation was to rival that of the Florentine masters. Another, Benvenuto Cellini, said that the cartoons had been 'a school for the entire world' – while they lasted. Both were destroyed (Michelangelo's, it seems, through being cut up, dispersed, and continually handled by copyists), and they cannot now be reconstructed in full. Some preparatory drawings survive, and there are more or less convincing copies of the main scenes by other artists.

The central episode in the *Battle of Cascina* showed Florentine soldiers roused by a sudden alarm while bathing – a perfect occasion for Michelangelo to display the male nude in a great variety of dramatic and expressive postures. Though contemporaries praised Leonardo's cartoon with almost equal enthusiasm, they were far more deeply influenced by Michelangelo's. At the 'school for the entire world', men learned to regard the nude in violent action as the highest form of artistic expression, a lesson that was to affect the whole course of European art.

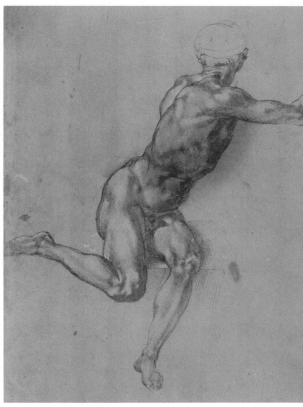

Figure study for the Battle of Cascina. 1504. British Museum, London.

The Divine Michelangelo

Pope Julius II, who summoned Michelangelo to Rome in March 1505, had been elected to the papal office two years before. As Giuliano della Rovere he owed his advancement – including his cardinal's hat – to his uncle, Pope Sixtus IV. Such nepotism (the favouring of 'nephews', who were sometimes actually illegitimate children) was common in the higher levels of the Renaissance Church; it had already resulted in the creation of two Borgia popes, and in Michelangelo's lifetime would lead to the elevation of two members of the Medici family whom he had known since boyhood. Nevertheless, Julius was not a pampered time-server but a man whose relentless energy and towering ambition were comparable with Michelangelo's. He was one of the greatest men of his time, though not a great churchman except in the most worldly sense. He brought the unruly Papal States back under control by personally taking command of his army and sharing its hardships, behaving in his sixties like an antique hero such as his namesake Julius Caesar; and later he was largely instrumental in driving the French out of Italy by a combination of war and diplomacy.

Between campaigns, Julius collected Classical statuary and elaborated ever

Laocoön. *c.*50 B.C. Discoveries of ancient art greatly influenced Renaissance men, who were passionate classicists. The *Laocoön*, dug up on the Esquiline Hill at Rome in 1506, powerfully reinforced Michelangelo's interest in rendering violent movement in sculpture. Musei Vaticani.

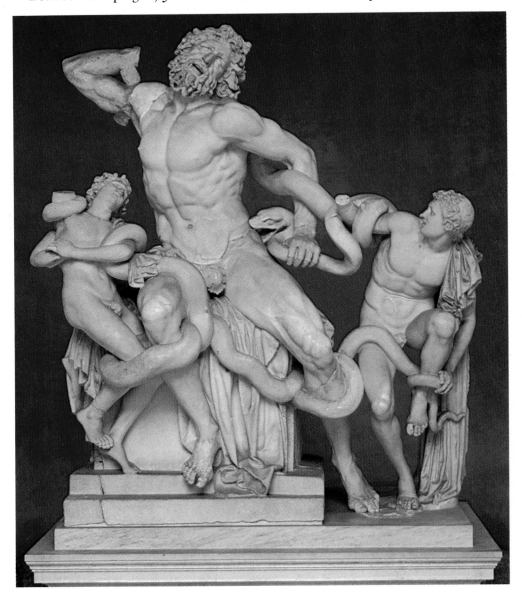

Raphael. *Pope Julius II*. A portrait of Michelangelo's patron by a young artist of extraordinary facility. Michelangelo, ever jealous and suspicious of others, regarded Raphael as a dangerous enemy. Galleria degli Uffizi, Florence.

more grandiose schemes of art and building to glorify himself, the papacy, and the city of Rome. Thanks to him, Rome began to attract all the leading artists of the day, and rapidly replaced Florence as the cultural capital of Italy during the period we now call the High Renaissance.

Julius is said to have brought Michelangelo to Rome without having a definite task in mind for him to perform, possibly acting on the advice of his architect Giuliano da Sangallo, who was a close friend of Michelangelo's. If so, pope and sculptor agreed with remarkable speed on a project of epic dimensions: a huge, fortress-like tomb for Julius, which was to be inhabited by over forty large free-standing marble figures. Michelangelo contracted to finish the work within five years, and was to be paid 10,000 ducats. By April he had left for Carrara, the great Italian marble quarries some 100 kilometres north-west of Florence, where he spent several months supervising the cutting and transportation of the stone. Early in 1506 he was able to begin working in his studio near St. Peter's, encouraged by regular visits from an affable Julius.

So began 'the tragedy of the tomb', which was to torment Michelangelo in one form or another for over thirty years. As originally visualized, it was more ambitious than anything that had been attempted since Roman times. Memories of antiquity haunted Julius, as they haunted Michelangelo, stirring up feelings of rivalry and stimulating megalomania. The great papal refuge and stronghold in the city, directly linked to the Vatican by a covered passage, was the circular fortress known as the Castel Sant' Angelo but originally constructed as the mausoleum of the Emperor Hadrian – an ever-present incitement to a pope who

also wished to immortalize his own mortality. The Roman atmosphere of Classical enthusiasm was intensified by the buried treasures that had begun to be unearthed; Julius himself had acquired a fine collection of Classical statuary which included the famous *Apollo Belvedere* (so called because it was housed in the Belvedere Palace in the Vatican). But the most thrilling find of the generation was made by a householder on the Esquiline Hill in January 1506. He reported that he had uncovered a statue, and the Pope sent word to Giuliano da Sangallo to investigate. As it happened, Michelangelo was with Sangallo when the message arrived, and the two men went together. As soon as he saw the statue, still half-buried, Sangallo exclaimed, 'This is the *Laocoön* mentioned by Pliny!' – a nice illustration of the passionate attention with which the ancient authors were then read. As a result, the *Laocoön* was purchased by Julius and set up in the Belvedere Palace. It is in fact a marble group, representing the Trojan priest Laocoön and his sons being slain by a gigantic serpent; the powerful, writhing naked bodies and the tremendous anguish and tension they generate were an inspiration to Michelangelo, apparently confirming that his chosen direction was classically correct as well as temperamentally congenial.

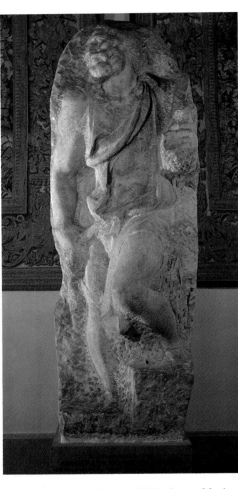

Below: *St. Matthew. c.* 1506. In 1503 Michelangelo was commissioned to carve twelve Apostles for Florence Cathedral. This magnificent unfinished figure is the only one he seems to have started. Accademia, Florence.

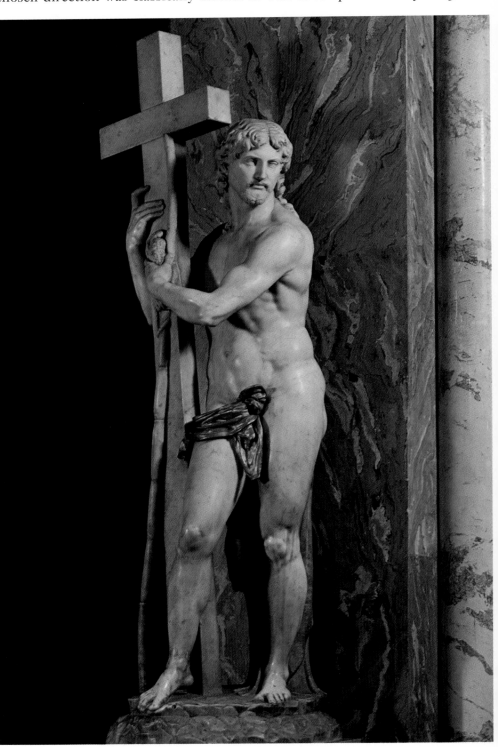

Right: *The Risen Christ.* 1521. Santa Maria sopra Minerva, Rome.

Actually Greco-Roman art was more stylistically diverse than Michelangelo and his contemporaries realized, but they had no reason to doubt the encyclopaedist Pliny's judgement that the group was the supreme achievement of sculpture, and were influenced accordingly.

Within a short time, Michelangelo's five-year plan was disrupted. Julius decided to go ahead with a scheme even more costly and ambitious than the tomb: he would have the venerable but dilapidated church of St. Peter's pulled down, and build a magnificent edifice to cover the bones of the Apostle and house his own tomb. In effect this meant deferring the execution of the tomb while vast quantities of money and papal attention were diverted to this latest exercise in the colossal – an exercise that was to last for well over a hundred years, involve a succession of great architects, and drive the papacy to the desperate and dubious financial practices already described. While the new project went ahead, Michelangelo was ignored. With amazement he overheard the Pope say that he would spend no more money on marble. Day after day he appealed for money to reimburse him for transportation costs, and at the end of a week he was simply refused admittance to the palace and chased away.

Below: *Atlas*. Unfinished marble figure, originally intended for the tomb of Pope Julius II. Accademia, Florence.

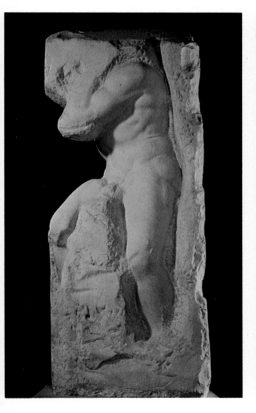

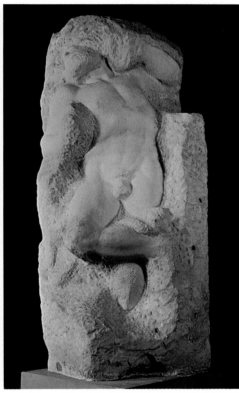

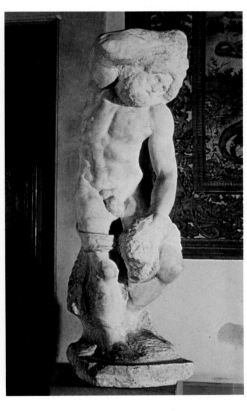

Above, centre: *Awakening Giant*. An unfinished marble figure, originally intended for the tomb of Pope Julius II. Like many similar figures by Michelangelo, it seems to be struggling to free itself from the surrounding marble. Accademia, Florence.

Above: *Slave* or *Prisoner*. Unfinished marble figure, originally intended for the tomb of Pope Julius II. Accademia, Florence.

Michelangelo's reaction was arguably over-hasty. On 17 April 1506 he fled from Rome – literally fled, since he knew that Julius could have him brought back by force if he was overtaken on papal territory. In a letter to Giuliano da Sangallo he recounted his grievances against the Pope, and hinted that his life had been in danger at Rome. This probably refers to some intrigue on the part of Donato Bramante, the appointed architect of the new St. Peter's, whom Michelangelo regarded as a deadly enemy. Whether his fears were anything more than an expression of paranoia is impossible to say at this distance in time, but it is evident that Michelangelo's tensions and anxieties erupted in panic-stricken flight on several occasions; he had earlier left Savonarolan Florence with the abruptness of flight, and would later desert his native city in the middle of a crisis. In his dealings with the Pope, however, Michelangelo had genuine grievances, and when papal horsemen caught up with him at Poggibonsi, safe on Florentine territory, he told them he would return only if Julius was ready to fulfil his promises.

Over the next few months the Pope made several attempts to conciliate or command Michelangelo, but the sculptor distrusted his promises of forgiveness and offered to go on working for Julius . . . in Florence. Finally, the Gonfaloniere of Florence, Pietro Soderini, remarked to Michelangelo, 'You have taken on the Pope in a way the King of France would not have dared to,' and told him that, since the Florentines were not prepared to risk a war with Julius

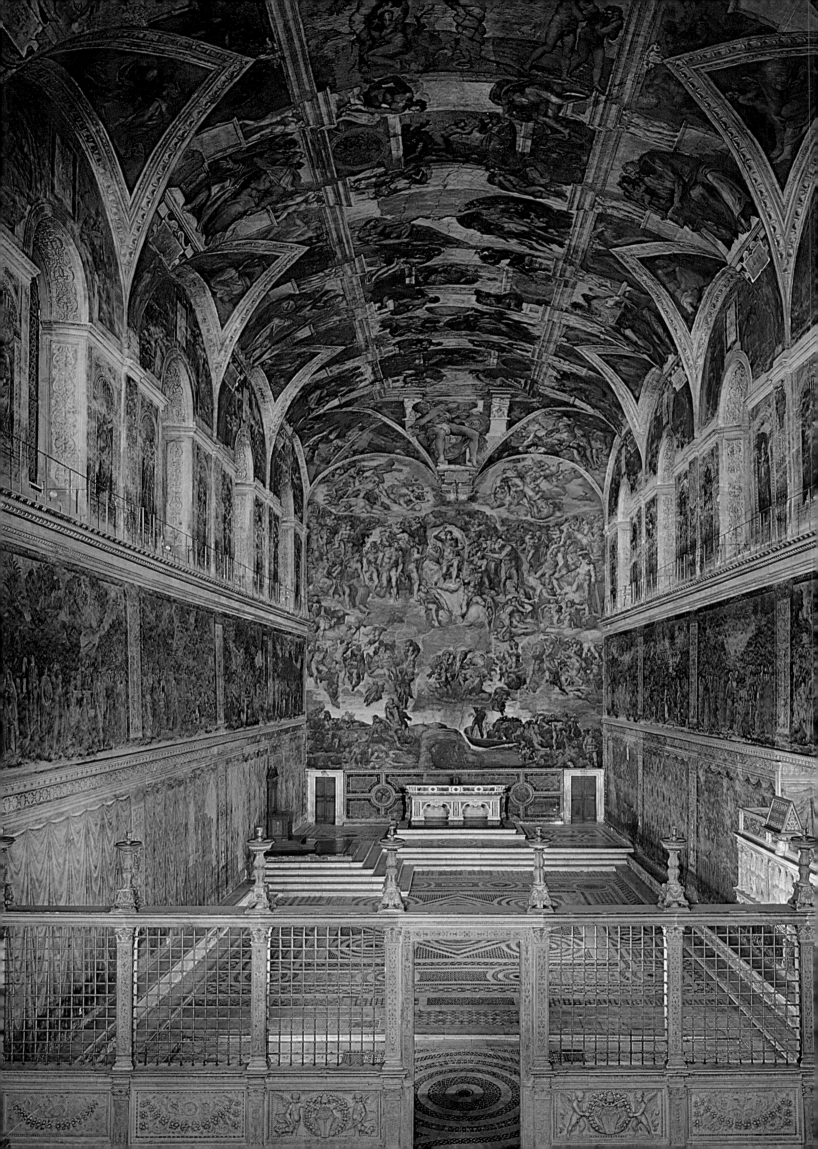

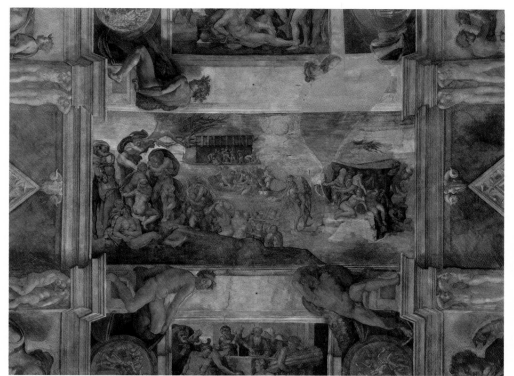

Left: The Sistine Chapel. Michelangelo was commissioned to decorate the vaults of the Sistine Chapel in 1508. An unparalleled physical achievement, its completion made him in a sense the first 'modern' painter, in that both the conception and the execution were the work of one man.

Left: 'The Flood' from the ceiling of the Sistine Chapel. 1509. The tight drawing of this scene reveals its early date; as Michelangelo worked on the ceiling his style became increasingly free and confident. Vatican.

on his account, he must make up his mind to go back to Rome. Putting aside panicky thoughts of fleeing to Turkey, Michelangelo gave himself up to the Pope at Bologna in November 1506, no doubt relying on the fact that Julius had just entered the rebellious town in triumph after a successful campaign, and would be in a magnanimous mood. Wearing a rope round his neck in token of submission, he flung himself on his knees, begged the Pope's forgiveness, and explained that he had not acted maliciously but in anger at being treated with apparent contempt. When Julius failed to reply, a bishop who was present sought to excuse Michelangelo by saying that he was only a painter and knew no better, whereupon the Pope turned on the unfortunate ecclesiastic, abused *him* for insulting Michelangelo, and had him roughly bundled out of the room. Having vented his anger on the bishop, Julius gracefully forgave Michelangelo and set him to work in Bologna.

His task was to make a colossal bronze statue of Julius, perhaps as a reminder to the Bolognese that rebellion did not pay. He disliked the commission and protested that he had no experience of casting bronze; and indeed the whole technique was alien to him. It involved making a model of the statue in clay, which was then transformed by means of a series of moulds and casts into a hollow bronze ready for a final working-over and polishing. The principal creative element in the process was the building-up of the clay, an activity quite distinct from the taking-away principally involved in stone sculptures. A good many masters have been equally adept at both, but Michelangelo was infinitely happier when carving; when doing so, he seems to have worked in a kind of trance-like condition, and to have experienced the appropriately Platonic sensation that he was discovering rather than creating – chipping away the stone to reveal the figures concealed in it. There was to be no such joy for him at Bologna; the work was uncongenial, so little accommodation (or perhaps money) was available that he had to share a bed with three other men, he quarrelled with his assistants, and there was an outbreak of plague. But the model was made and, after one failure, the tricky job of casting the bronze was accomplished. In February 1508 it was put on show in the church of San Petronio, and Michelangelo went home to Florence. In December 1511 the unruly Bolognese revolted again and broke up the statue; the head came into the possession of Julius' enemy Alfonso of Ferrara, who recast it into a culverin which he mockingly named 'La Giulia' (the female equivalent of Giulio, i.e. Julius).

THE MIRACLE OF THE SISTINE
Michelangelo evidently intended to settle in Florence for the duration. He leased living quarters in the city, and had been promised a block of marble from which to carve a *Hercules*, about the same size as the *David*, for the Piazza della

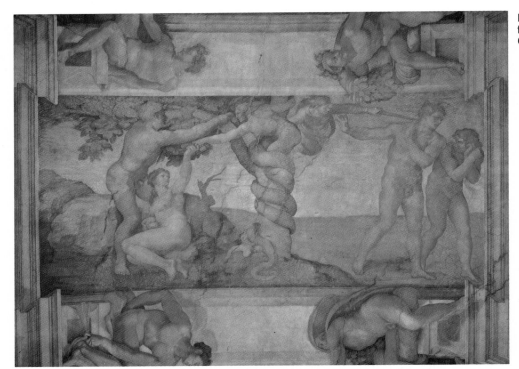

Left: 'The Fall of Man and his Expulsion from Eden' from the ceiling of the Sistine Chapel. 1509–10. Vatican.

Below: 'The Creation of Adam' from the ceiling of the Sistine Chapel. 1511. Vatican.

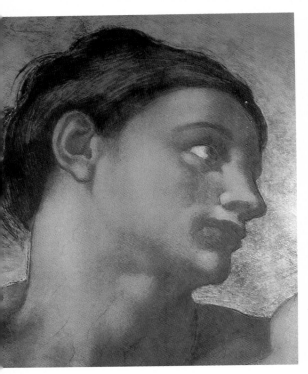

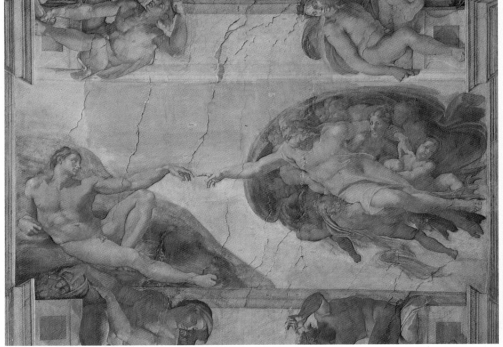

Above: Detail of the head of Adam from the 'Creation of Adam'; Sistine Chapel ceiling. 1511. Vatican.

Signoria. Instead he received a new summons from Julius II and, no doubt chastened by the outcome of his earlier disobedience, promptly set off for Rome. The promised marble did arrive in Florence, and was eventually awarded to Michelangelo's hated rival Baccio Bandinelli, whose mediocre *Hercules and Cacus* still stands in the Piazza alongside a copy of the *David* (the original is now in the Accademia, Florence, safe from weathering and vandalism).

If Michelangelo hoped to take up work on Julius' tomb again, he was to be disappointed; the Pope wanted him to put off the (highly expensive) tomb project and paint the ceiling of the Sistine Chapel that stood next to the Vatican Palace. The main account of how this commission came about is to be found in the biography of Michelangelo by Ascanio Condivi, which means that to all intents and purposes it is Michelangelo's version, transmitted in old age to a diligently note-taking young disciple. As might have been expected, it makes Michelangelo the victim of an intrigue and dramatizes his reluctance and difficulties in order to make his final triumph appear the more brilliant. In other words, the story is suspect; but it is nonetheless worth repeating. Bramante, of course, is the villain. He wanted to divert Michelangelo from work on the tomb

and, if possible, have him fail utterly at some important task. The Sistine Chapel ceiling was highly suitable for this purpose. It would be difficult to paint because it was a barrel-vault, curving down to meet the walls; at the same time, Michelangelo had no known experience of this kind of work, despite his willingness to paint the *Battle of Cascina* for the Florentine Signoria. Apart from its intrinsic importance, the Sistine Chapel meant a great deal to Julius because it was a family creation, built by his uncle Sixtus IV. The walls already carried paintings by older masters (Perugino, Botticelli, Signorelli and Michelangelo's old master Ghirlandaio) which would show up any failures on Michelangelo's part; and he would be further humiliated by the brilliant success anticipated for Raphael of Urbino – actually a relative of Bramante's – in the wall-paintings he was to execute in the library of Julius' apartments in the Vatican. With these considerations in mind, Bramante exerted himself to persuade the Pope that Michelangelo was the very man to paint the Sistine ceiling.

Such was the 'plot' as Michelangelo saw it, even fifty-odd years after the event. The fact that Bramante was the greatest architect of his time does not make it impossible that he should have been an arch-intriguer, though some of Michelangelo's accusations are obviously wild (notably that Bramante was a spendthrift who short-changed the Pope by using inferior building materials, and therefore lived in fear of exposure by Michelangelo). Even if the story has been distorted by Michelangelo's paranoia, it is of interest in allowing us to glimpse the kind of intrigues that occurred in the Renaissance world of lavish patrons and ambitious rival artists.

Below: An 'Ignudo' (nude) from the ceiling of the Sistine Chapel. 1511. One of twenty naked youths whose significance in the scheme of the ceiling is obscure. The early figures are purely decorative; later examples, like the one illustrated here, have tremendous force and potency. Vatican.

Left: 'The Creation of the Sun, Moon and Plants' from the ceiling of the Sistine Chapel. 1511. Vatican.

Below: 'The Prophet Jeremiah' from the ceiling of the Sistine Chapel. 1511. Vatican.

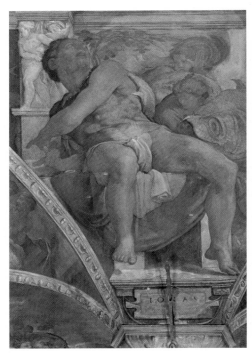

Above: 'The Prophet Jonah' from the ceiling of the Sistine Chapel. 1511. The Biblical story of Jonah, delivered from the sea-beast Leviathan, was held to foreshadow the Resurrection of Jesus. This probably explains why Michelangelo painted the figure above the altar of the chapel. Vatican.

Right: 'The Cumaean Sibyl' from the ceiling of the Sistine Chapel. 1510. This Sibyl is said to have sold King Tarquinius of Rome the prophetic books ('Sibylline Books') which the Romans consulted in every crisis. Vatican.

Michelangelo did everything he could to avoid the Sistine commission; according to his own account, he even told the Pope that his 'enemy' Raphael was a more suitable choice. But opposition only made the Pope more angry and insistent, and in May 1506 Michelangelo submitted and began the preliminary work. Feeling in need of expert advice, he sent for five Florentine artists to assist him; one was an old friend, Francesco Granacci, who is supposed to have introduced him to Lorenzo de' Medici's sculpture school almost twenty years before. Nevertheless, Michelangelo quickly fell out with his helpers, sent them all away, and shut himself away on his own in the chapel, determined to carry out the whole work by himself. This was a characteristically eccentric decision in an age when workshop assistants were habitually employed to 'fill in' many of the less important details on a large-scale work; and in fact the practice remained common for centuries more. But it was just this insistence on 'signing' every inch of his work – on creating an unmistakeable personal style – that made Michelangelo (like Leonardo before him) a 'genius' in a sense that would have been meaningless to one of the old workshop-master artists.

And despite his protestations of incompetence, it was Michelangelo himself who transformed the Sistine commission into a labour of Herculean dimensions. Julius had asked him to paint an Apostle in each of the twelve spandrels – the large triangular areas linking the barrel-shaped ceiling with the arches at the tops of the walls; the enormous area above the spandrels was to be an ornamental design of circles, rectangles and similar features that would have been relatively simple and quick to execute. Instead, Michelangelo persuaded Julius to approve the vastly more ambitious work that we see now – some 5,600 square feet (520 sq m) thronged with figures and scenes and architectural elements. It cost him almost four years of physical suffering, working in unnatural positions on special scaffolding. Legend has him painting on his back or side, but a little sketch he made of himself shows him standing to work, his head thrown back, and in the accompanying poem he complains of the paint falling in his eyes and of the twisting and craning that was turning him into a kind of monster. After a day's work, it is said, he could only read a letter from his father or brothers by holding it above his head.

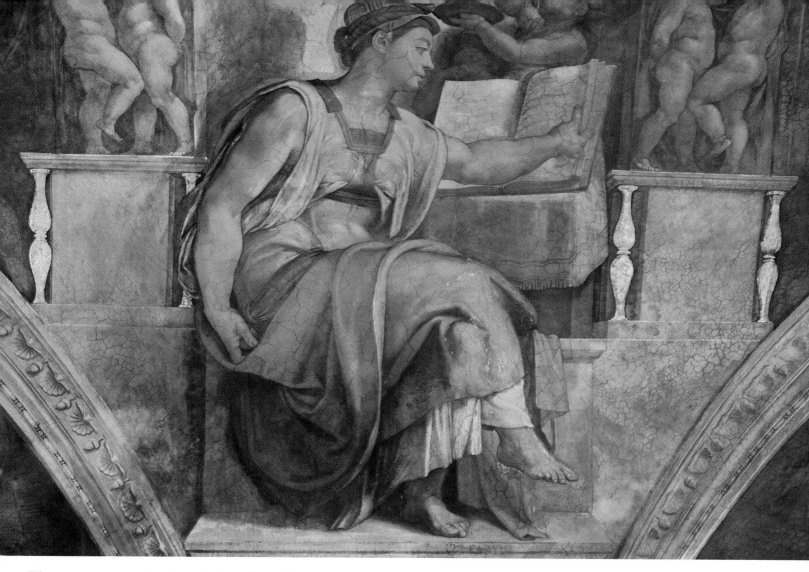

There were occasional periods of respite, usually when Michelangelo's money ran out. Twice he was compelled to ride to Bologna and beg Julius to see the work through. Julius complied, though with increasing impatience at Michelangelo's refusal to commit himself to a finishing date. Even Michelangelo could not keep the Pope out of the chapel, and the indomitable sixty-nine-year-old would climb a ladder to the scaffolding with a helping hand from the artist. When would he be finished? 'When I can,' said Michelangelo – as he always said. At last the Pope lost patience and lashed out at Michelangelo with his stick; he repented when Michelangelo rushed away as if to leave Rome, and sent a messenger to mollify him (with money); but the quarrel only broke out again the next day, and when Julius threatened to have him thrown from the scaffolding, Michelangelo thought it prudent to allow the chapel to be thrown open. On 31 October 1512 the notables of Rome came, saw and were conquered. In the eyes of contemporaries, Michelangelo had done more than establish that he was as great a painter as he was a sculptor. By the heroic scale of his achievement he had gone altogether beyond the plane of comparisons; he was superhuman, unique, 'divine', and still only thirty-seven.

Technically speaking, the painting of the Sistine Chapel was entirely orthodox. We have seen that Leonardo da Vinci ruined his *Last Supper* and *Battle of Anghiari* by mixing oil into his pigments to achieve subtle effects of modelling. Michelangelo employed the traditional *fresco* technique, which has proved its worth over the centuries by preserving not only the Sistine but a great many other wall- and ceiling-paintings. Fresco ('fresh') consists essentially in applying water-based colours on to a fresh, slightly damp plaster surface; a chemical reaction takes place during drying and bonds paint and plaster together, so preventing flaking and most other forms of deterioration. Because the plaster had to be damp, only a limited amount could be applied in a given session, and the painter had to work quickly or he might be forced to scrape the plaster off and begin the whole process over again; corrections and second thoughts were similarly inhibited. For this reason fresco painting was an art of broad effects, well suited to Michelangelo's mature genius. His growing mastery is apparent in what we know of his technique and also in what we can see in the

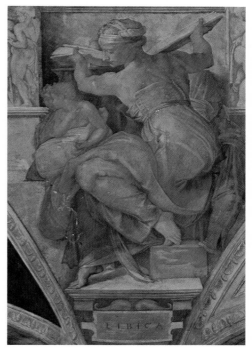

Top: 'The Erythraean Sibyl' from the ceiling of the Sistine Chapel. 1509. This Sibyl is said to have prophesied the Last Judgement. Vatican.

Above: 'The Libyan Sibyl' from the ceiling of the Sistine Chapel. 1511. Legend had it that this Sibyl prophesied the advent of Jesus. The twisting torso (*contraposto*) is a characteristic feature of Michelangelo's style. Vatican.

ceiling itself. At first he used his cartoon in traditional fashion, pinning it to the fresh plaster and dusting it with charcoal; the charcoal passed through holes pricked along the lines on the cartoon, so that when the cartoon was removed the outline design was left on the plaster in charcoal. Later on he abandoned charcoal and simply used a stylus to press along the lines in the cartoon, making grooves in the plaster behind it that served as his outline. The grooves can still be seen from close up, as can the increasing freedom with which he treated his own design, modifying it according to the inspiration of the moment – an expression of supreme confidence when working in a medium that put such a high premium on careful preparation and penalized errors so severely. In fact Michelangelo picked up speed to such an extent that by 1512 he was covering astonishing areas of ceiling every day. The increasing freedom with which he worked is apparent in the figures themselves, which begin as relatively small, tightly drawn and sculpturesque ('The Flood') and grow progressively larger and freer, until the prophets spill out of the niches that are supposed to hold them, and the powerful naked youths encroach upon the corners of the central panels.

To the modern spectator, the ceiling of the Sistine Chapel is above all a celebration of human beauty and energy, rendered with such fullness and insistence that they endow even Michelangelo's sinners and sufferers with an aura of greatness. Compared with the art of previous centuries, Michelangelo's is emphatically man-centred. Yet despite its intense physicality, it represents an elaborate intellectual – religious scheme which, though it may owe something to outside theological advisers, seems mainly to reflect the shared neoplatonic outlook of Julius II and Michelangelo himself. Neoplatonism, as we have seen, tended to identify physical and spiritual beauty, and to attempt a reconciliation of Classical, Hebrew and Christian traditions. In some respects this was merely an extension of a long-established method of Christian interpretation which claimed to find anticipations of Christ's coming in Roman authors such as Virgil, and both literal and symbolic prophecies of it in the Old Testament. Jonah, for example, was equated with Christ because he spent three nights in the darkness of the leviathan's belly before being 'resurrected'. Such analogical procedures, especially when used to create ambitious intellectual schemes, are alien to the modern mind, but they were the stuff of Western thinking for centuries. To understand this is to add an extra dimension to our appreciation of the Sistine ceiling, though only a specialist would be interested in unravelling its multiplicity of meanings and allusions, many of them debatable.

The divergence between the literal and the symbolic is present at the heart of the work – the nine panels running down the centre of the ceiling. On one level they complemented the paintings on the wall below, which contrasted the life of Moses (the Old Law) with that of Jesus (the New Dispensation). Michelangelo's panels go back to the age *before* the Law, beginning with the Creation and taking the story of the Book of Genesis through the Fall of Man to the Flood and the Drunkenness of Noah. Seen in this way, the story is the gloomy one of Man's iniquity; however, Michelangelo did not intend the panels to be experienced in this (to us) natural chronological order, but in reverse. Anyone who entered the chapel would see the Drunkenness of Noah first, and would then proceed towards the supreme manifestations of God's love – the Creation and, in the symbolic form of Jonah above the altar, Christ. It may not be over-fanciful to suggest that Michelangelo was consciously undertaking a symbolic pilgrimage in beginning his work at the entrance and progressing with such suffering towards the altar and salvation. Even the increasing size and free treatment of the figures, though probably resulting from Michelangelo's growing skill and experience, fit happily into the swelling triumphal theme.

The panels are surrounded by twenty naked youths (*ignudi*, 'nudes'), arranged in pairs on either side of a series of 'bronze' medallions. The function of the *ignudi* – or Michelangelo's excuse for including them – has been the subject of fierce arguments. Some scholars have claimed that they represent angels, but if so they are angels so thoroughly disguised as nudes after the style of antiquity that the disguise is more convincing than the supposed reality. Doubtless a neoplatonic explanation comfortably equated physical beauty with beauty of soul, and beauty of soul with truth . . . and so on. However, the emotional basis of Michelangelo's neoplatonism is apparent in the transformation of the *ignudi* from rather tame decorative figures to overwhelming images of male force, whether potent at rest or swept up into violent action as if by some invisible tempest.

Right: The Tomb of Pope Julius II. Michelangelo's grandiose plans for this tomb involved him in difficulties that tormented him for thirty years. As it now stands, only the three figures at ground level are his work. San Pietro in Vincoli, Rome.

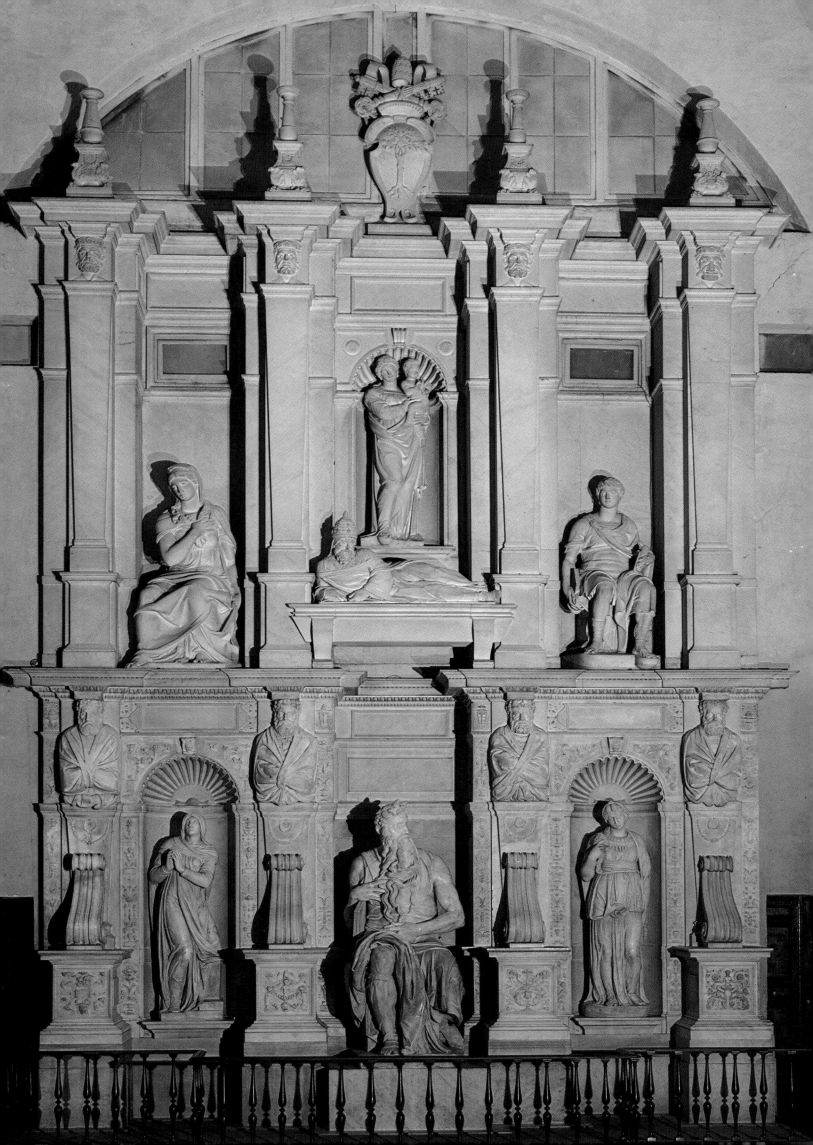

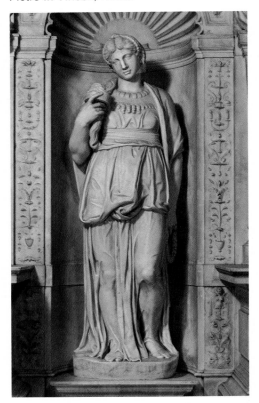

Below: From the tomb of Pope Julius II. *c.* 1542. *Leah* or *The Active Life* (top) and *Rachel* or *The Contemplative Life*. San Pietro in Vincoli, Rome.

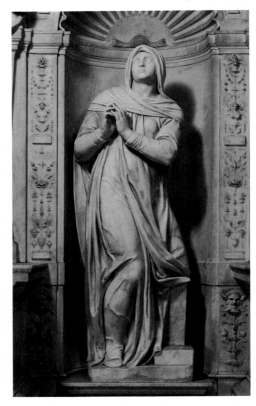

Far right: *Moses*. 1513–16. This statue of the Hebrew lawgiver is the centre-piece of the tomb of Pope Julius II, for whom Michelangelo painted the Sistine Chapel ceiling. San Pietro in Vincoli, Rome.

The prophets and sibyls, filling and sometimes overfilling the niches below the central panels and *ignudi*, possess a more massy power. The prophets are Old Testament figures; the sibyls are the half-legendary prophetic women of antiquity, conjuring up memories of King Tarquinius and ancient Rome in the mind of the viewer well-read in the classics. Both are included as supposedly foretelling the coming of Christ. The entire ceiling composition is framed in a painted architecture in which Michelangelo has included still more naked figures 'supporting' painted columns or filling available spaces; the figures dominate and obscure the architecture, not vice versa. The work continues on to true architectural features – the spandrels, the lunettes (semi-circular areas at the tops of the wall arches), and the four pendentives or double-spandrels in the corners. Here the subjects are the ancestors of Jesus (spandrels and lunettes) and four crises in Old Testament history (pendentives), including a Hanging of Haman and a Brazen Serpent which in tortuousness and density anticipate the more troubled, turbid mood of Michelangelo's later painting.

THE YEARS OF FRUSTRATION

After finishing his work on the Sistine, Michelangelo seemed to have the world at his feet. He was universally recognized as the greatest living artist, with all the privileges and opportunities that implied, and he could look forward to at least twenty years of creative activity. In the event, they were to be years of intense frustration and only partial achievement; ironically, the last, unlooked-for twenty years of his life, which took him into extreme old age (by the standards of the time), were at least as fruitful and personally more fulfilling.

In February 1513 Julius II died at the height of his power and achievement. In the previous year he had brought Parma and Piacenza under papal rule, fought off a French-inspired threat to his ecclesiastical authority, crowned his diplomacy by forging a coalition that drove the French from Italian soil, and displayed to the world a Sistine Chapel that was virtually a memorial to the della Rovere family. (A few hundred years later, it is easy to forget that a work like the Sistine shed at least as much glory on those who named and paid for it – Sixtus and Julius – as on the artists involved.) Despite their differences Michelangelo had admired the Pope, but Julius' death must have seemed rather well timed; the project for his tomb, which Julius had deferred for so long, as though convinced of his own immortality, would surely now be urgently taken in hand by his heirs. And so it proved: Michelangelo signed a new seven-year contract in May 1513, and set to work with a will.

Meanwhile, power relations in his world had been revolutionized. Republican Florence had mistakenly taken a pro-French line, and was swept away in the aftermath of the French defeat; the Pope's Spanish allies entered the city in September 1512 and reinstalled the Medici, who thus benefited from the close association between Julius II and Cardinal Giovanni de' Medici, the second son of Lorenzo the Magnificent. Six months later, on Julius' death, Giovanni was unexpectedly elevated to the papal throne as Leo X, and the Medici found themselves in power at both Rome and Florence, the two worlds of Michelangelo. This situation lasted with hardly a break for twenty years, during which time the Medici were the most important single influence on the artist's life.

For three years, however, Michelangelo was allowed to work on Julius' tomb without disturbance. Although Leo was bringing artists, writers and musicians from all over Italy to Rome, he evidently respected Michelangelo's dedication to the tomb of Julius, the pope who had done so much to restore the Medici fortunes; such an act of generosity was not too painful for Leo, since he had at hand the prolific and reliable Raphael, now at the height of his powers and capable of tackling any major project with less fuss than unpredictable 'supermen' like Michelangelo and Leonardo (who seems to have been virtually ignored when he came to Rome at this time).

The only sculpture Michelangelo completed in this three years of work was a great seated figure of Moses with the tables of the Law. There is perhaps no other statue in which an attitude of repose has been so imbued with pent-up energy. Staring fiercely to one side, with muscles bulging, veins standing out on his hands and arms, and his fingers tangled in his torrentially flowing beard, the Hebrew lawgiver looks as though he might rise to his feet at any moment and break out in a fury of righteous wrath. When the *Moses* was finally set up in San Pietro in Vincoli, the Jews of Rome flocked around it every Sabbath 'like

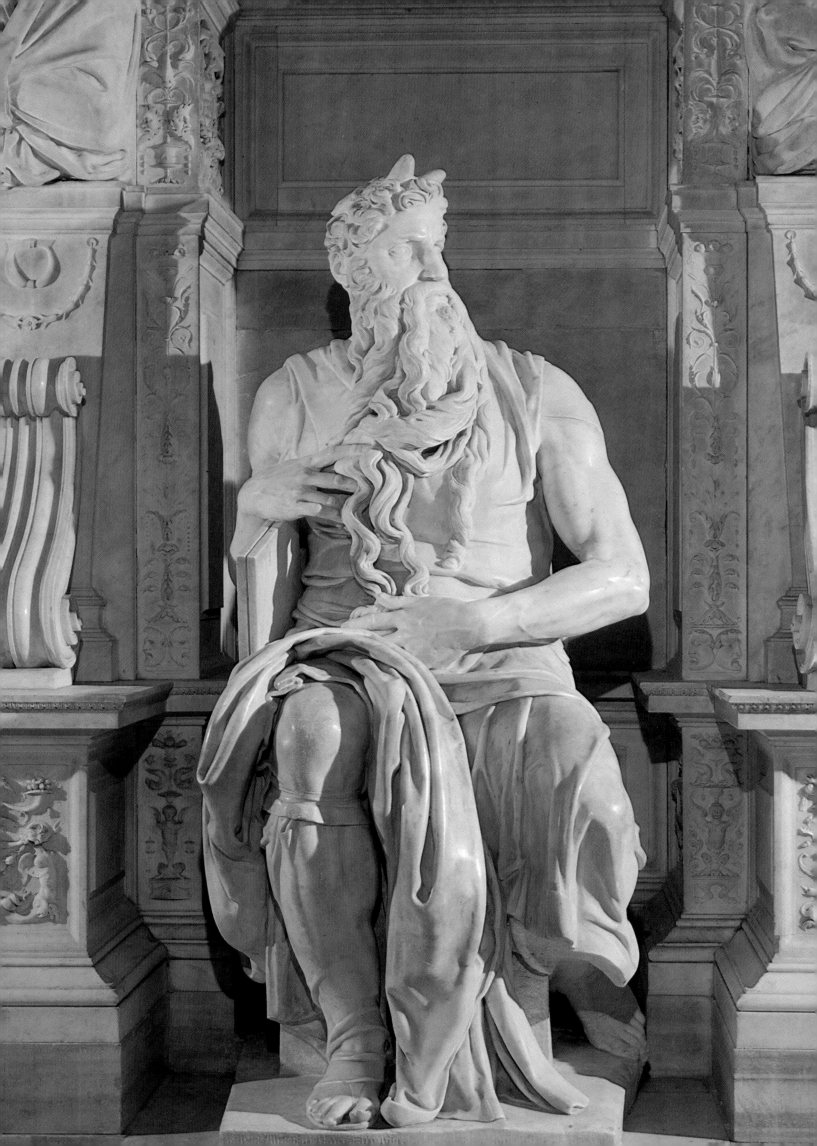

Right: *Dying Slave*. 1513–16. This marble figure, which is not quite finished, was originally intended for the tomb of Pope Julius II. Below is a detail from the sculpture. Musée du Louvre, Paris.

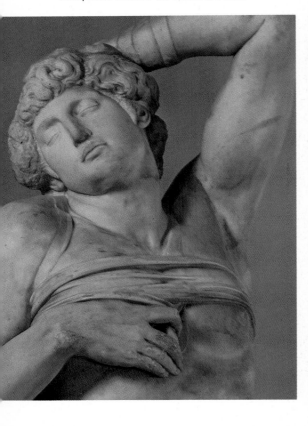

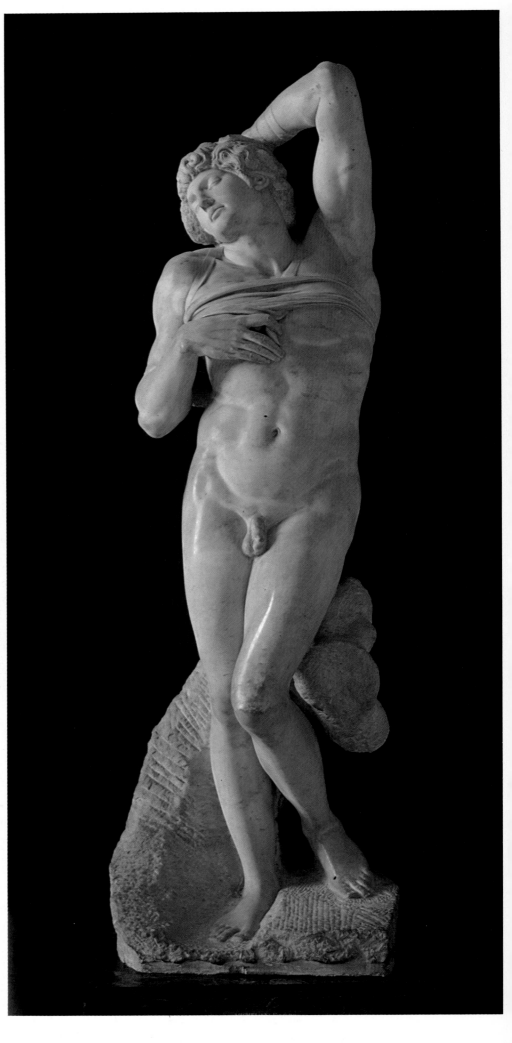

starlings', said Condivi, who wrote approvingly of the adoration they lavished on the statue 'since they are adoring something that is divine rather than human'. Legend has it that Michelangelo was so transported by his own work that he flung his hammer at it, commanding it to speak — which is, if nothing else, a picturesque way of accounting for a mark that can be seen on Moses' knee. To the modern eye, the most curious feature of the statue is the pair of horns on Moses' head. These were in fact traditional in Christian representations of the lawgiver, deriving from a mistranslation of the Hebrew 'rays of light' in the Vulgate, the Latin version of the Bible. By Michelangelo's time the error had been detected, but he either did not know of it or preferred to retain the traditional iconography.

During these years he brought two other figures for Julius' tomb to near-completion, the *Dying Slave* and the *Rebellious Slave*; the names are convenient rather than informative, since the tomb project underwent so many changes of plan that it is impossible to say what function they were supposed to fulfil in it. The erotic languor of the *Dying Slave* is extraordinary, whatever its programmatic significance (which is almost certainly to do with sleeping or arousal rather than death); and the *Rebellious Slave* relates back to the struggling Sistine *ignudi* while foreshadowing later 'captives' — 'unfinished' figures that seem engaged in a titanic struggle to liberate themselves from the surrounding stone.

'The tragedy of the tomb' continued for almost another thirty years, during which Michelangelo was harassed and taken to law by Julius' relatives, who agreed to less and less ambitious contracts in the hope that Michelangelo would produce some kind of finished work. The end result — in 1545! — was a mockery of Julius' megalomaniac conception. Moses, originally intended as only one among many figures on the upper tier of the tomb, became the centrepiece of the present, relatively modest wall-tomb, which does not even rest in St. Peter's, as Julius intended, but in the church of San Pietro in Vincoli. Michelangelo decided that the 'Slaves' were too large for the final version of the tomb agreed in 1542, and substituted the rather uninspired figures of *Rachel* and *Leah* (also known as *The Contemplative Life* and *The Active Life*) which now flank *Moses*; and apart from these three, all the other figures on the tomb were finally carved by other hands than Michelangelo's. 'The tragedy of the tomb' was not the expenditure of Michelangelo's energy on the work, but the waste of it on negotiations, revised schemes and sheer agonies of worry. In classic neurotic fashion he tended to create such situations by taking on impossible tasks, and then to experience panic and paralysis in the face of the ensuing difficulties.

Detail of the *Rebellious Slave*. 1513–16. Also intended for the tomb of Pope Julius II. Musée du Louvre, Paris.

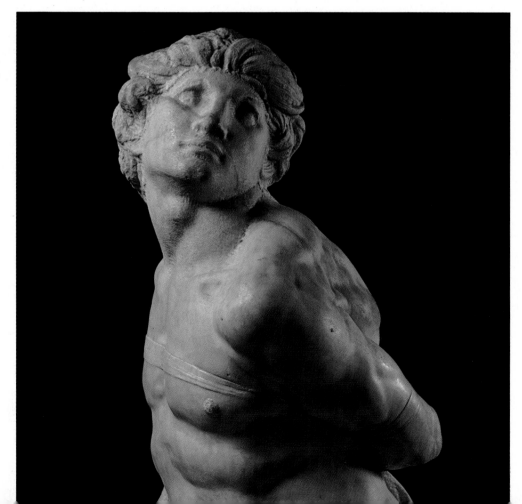

Michelangelo's next project was a four-year fiasco. To celebrate the renewal of his family's power, Leo X was anxious to have a magnificent façade erected for the Medici church of San Lorenzo in Florence. Michelangelo was certainly expected to participate; Leo had not called on his services for three years and, having violently fallen out with the della Rovere family, probably felt disinclined to wait while Michelangelo spent still more years carving a memorial that would reflect glory on them. In his old age Michelangelo liked to picture himself as being torn away from his work on Julius' tomb, but the evidence shows that he wanted the entire San Lorenzo commission for himself. As well as putting forward a design for the façade, he proposed to execute the numerous sculptures and decorations himself, rejecting the possibility of contributions from even his most distinguished contemporaries. With the della Rovere family discontented and a *Risen Christ* promised but not done for the church of Santa Maria sopra Minerva, this was extremely unwise, but the outcome was utter disaster. After well over three years of trying to get marble efficiently quarried and transported, Michelangelo had nothing to show for his efforts, and early in 1520 Leo cancelled the contract. To this day, the façade of San Lorenzo – church, landmark and treasure-house of Florence – is nothing more than a few dozen rows of rough, decaying brickwork. Michelangelo's one substantial achievement of the period was the *Risen Christ*, which was executed in Florence and sent to Rome in 1521. Some of the blame for the unsatisfactory nature of the work belongs to Michelangelo's assistant, Pietro Urbano, who was charged with setting it up

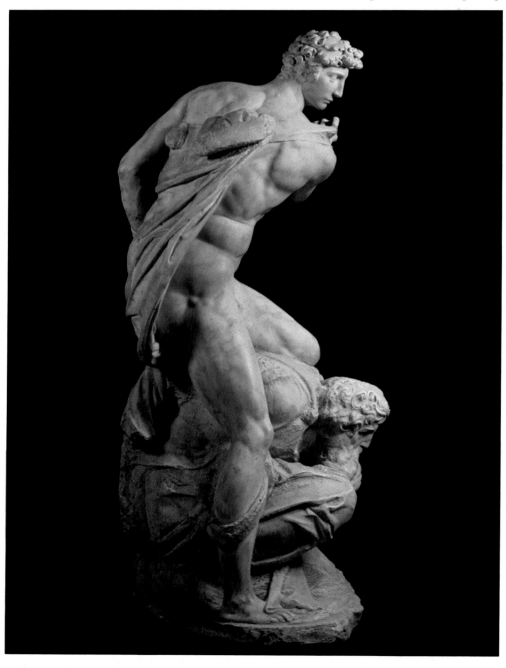

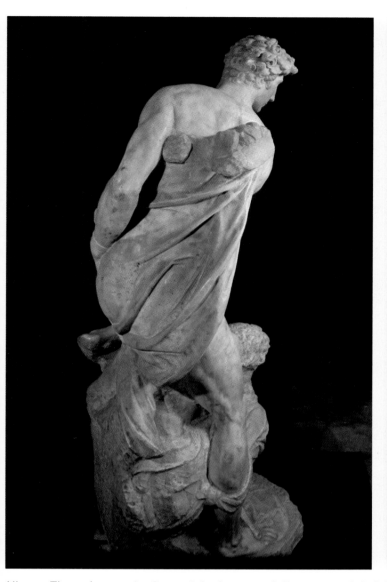

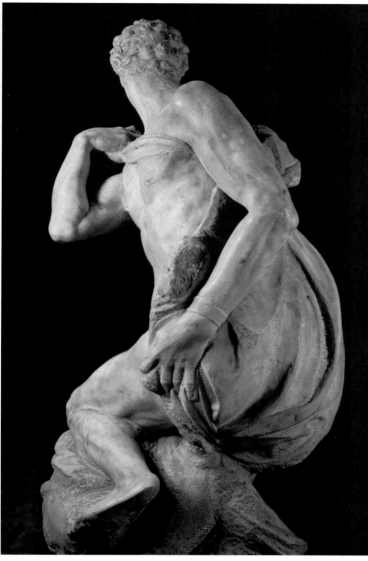

Victory. Three views of this curiously mannered sculpture which was probably carved while Michelangelo was serving the short-lived Florentine republic (1527–30). Palazzo Vecchio, Florence.

in Santa Maria sopra Minerva and finishing the details; he botched the job so badly that Michelangelo's friends made sure everybody in Rome knew that the work had not been executed by him. All the same, the heavily muscled torso and twisted posture of Christ represent the most uneasy example of Michelangelo's physical–neoplatonic–Christian synthesis.

Michelangelo's letters show that he was furious when the San Lorenzo façade commission was cancelled. However, he had by no means lost favour with the Medici, and a few months later became involved in a new project for San Lorenzo. This was to ramify into commissions to design a Medici Chapel, to carve four Medici tombs, and to create a great library for the church. Two of the tombs were to be for great men of an earlier generation – Lorenzo the Magnificent, Michelangelo's first patron, and his brother Giuliano de' Medici, who had been assassinated as long before as 1478, when Michelangelo was three years old. However, the real impulse for the project came from the untimely deaths of the only two Medici who were both legitimate and laymen – or, in other words, capable of carrying on the 'dynasty'. Mainly thanks to Leo X, his brother Giuliano had become duke of Nemours and his nephew Lorenzo duke of Urbino; their deaths in 1516 and 1519 seemed to end the prospects of the line just when it had begun to outgrow its merely republican greatness. However, Leo retained control of Florence for the time being through Cardinal Giulio de' Medici, the illegitimate son of the older Giuliano. These events were to have more than an artistic significance for Michelangelo; they were to involve him, briefly, in politics and war.

Medici projects were to be Michelangelo's chief concern for years to come, with Julius' unfinished tomb always in the background as a source of anxiety and alarm. When Leo X died unexpectedly in 1521 (he was still in his mid-forties), work for San Lorenzo was suspended and Michelangelo made an effort to pacify Julius' heirs by starting four more 'Slaves'. But he failed to get very

far with them, and the figures remain half-buried (so to speak) in the stone – which makes them exciting and moving to 20th-century taste, though we can be certain that Michelangelo's contemporaries felt nothing but regret that such promising works should not have been carved to the last detail and given a high finish.

The Medici were soon back in control in Rome. Cardinal Giulio was elected pope in 1523, after the death of Leo's short-lived successor, and this renewal of the family fortunes made it possible for work at San Lorenzo to go on; Giulio, now Clement VII, even added the building of the Laurentian Library to Michelangelo's already daunting list of tasks. The next few years were made particularly miserable for him by one of the periodic crises over Julius' tomb, in which he had now obviously lost all interest. Despite a drastic reduction of his obligations in the contract of 1516, he had produced nothing by 1524, when Francesco della Rovere, Duke of Urbino, set off a new round of recriminations and negotiations by threatening him with legal proceedings. The tone of Michelangelo's letters in the 1520s was frantic; he complained of being old and exhausted, he spoke of losing his mind and he utterly refused to contemplate going to law, saying that he preferred to imagine that he had already lost the case and had to pay up. He was rescued from these perplexities, in the sense that great disasters drive out small ones, by the events of 1527.

The most resounding of these was the sack of Rome that began on 6 May, when a leaderless mixed force of Spanish and German troops stormed the city in a frenzy of murder, rape and destruction. Nuns were bought and sold, cardinals ransomed, priests murdered, treasures melted down, manuscripts burned; some 13,000 Romans are said to have perished in the sack and its

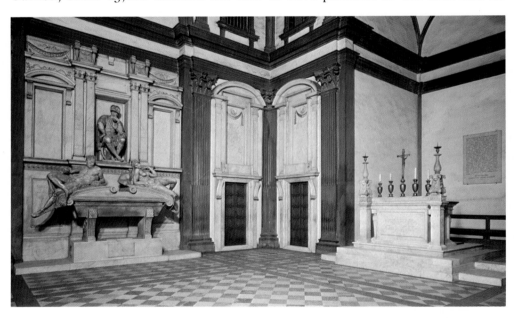

The Medici Chapel: the altar and the tomb of Lorenzo de' Medici. 1520–34. Both the design of the Chapel and the Medici tombs were the work of Michelangelo. Church of San Lorenzo, Florence.

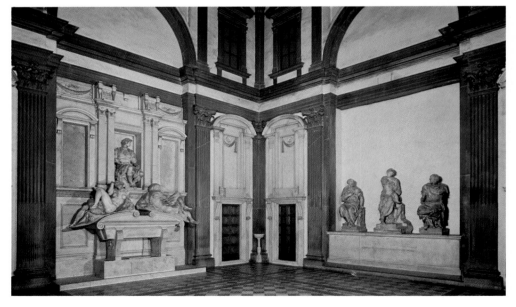

The Medici Chapel: the tomb of Giuliano de' Medici and the *Medici Madonna and Child*. 1524–34. Church of San Lorenzo, Florence.

aftermath. The catastrophe had long-term effects on the Italian mind, virtually ending the Renaissance and heralding the sombre and conformist Counter-Reformation mood. It also shattered the illusion of papal power fostered by Julius II; Clement, under siege in the Castel Sant' Angelo, eventually ransomed himself and fled to Orvieto in a state of near-destitution.

The Florentines took advantage of the situation to throw off the Medici yoke, which had grown increasingly burdensome since Cardinal Giulio's departure to become pope. Since then, Guilio/Clement had continued to exercise power in Florence through a nominee, the unpopular Cardinal Passerini, and had begun to groom an almost unknown Medici bastard, Alessandro de' Medici, to take over the family's power and possessions. Such actions made a mockery of the pretence that the current head of the Medici house was merely the first citizen of a free republic, and intensified suspicions that the Medici aimed to overthrow the republic entirely and make themselves hereditary and autocratic rulers. And so in May 1527 the Florentines took advantage of Clement's powerlessness; they abolished the Medicean constitution and re-created the republic, while Passerini and Alessandro fled.

Michelangelo soon became prominent in the affairs of the new republic, despite his long association with the Medici. Very little is known about his political ideas. His side eventually lost and, given the anti-republican atmosphere in which his old age was passed, he understandably maintained a discreet silence about such matters; but a few recorded conversations do indicate that he disliked 'tyrants' – as the Medici undoubtedly aimed to become – and approved of tyrannicide. At any rate he passed from an artistic-civic role in republican Florence (the *Hercules* project, symbolic of the old anti-Medici

Below: Detail of the head of Lorenzo de' Medici, from his tomb in the Medici Chapel. 1524–34. This is an 'ideal head' of Lorenzo, not a portrait; and the same is true of the figure of Giuliano. 'Who will know what they looked like in a thousand years time?' was Michelangelo's justification for this procedure. Church of San Lorenzo, Florence.

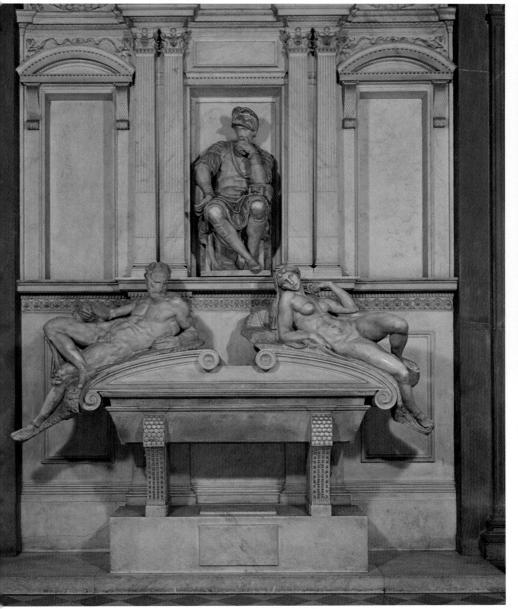

Left: The tomb of Lorenzo de' Medici in the Medici Chapel. 1524–34. Below the pensive, seated Lorenzo lie figures of Dawn and Evening. Church of San Lorenzo, Florence.

order, was briefly revived after nineteen years) to a place on the defence council of the city when a serious threat to Florentine independence took shape. After the sack of Rome, a chastened Clement VII submitted to the victorious Emperor Charles V and managed to arrange a marriage between Alessandro de' Medici and Charles's illegitimate daughter, who were to become duke and duchess of Florence. So the Emperor's German-Spanish army would now be turned against Florence, whose only resource was to try and hold out until one of Charles's other enemies (the French, the Turks, the Lutherans) became so troublesome that he was forced to march his men away to deal with them. Michelangelo was put in charge of the city's defensive works as 'Governor-General and Procurator of Fortifications', and although his more elaborate plans were not adopted he overcame his colleagues' sloth and fortified the hill of San Miniato, which he correctly identified as the key to a successful defence.

The employment of an artist in such tasks was not unusual during the Renaissance; Michelangelo's rival and *bête noire*, Leonardo da Vinci, had served both his native Florence and two of Italy's most notable tyrants, Lodovico Sforza and Cesare Borgia, as a military engineer. Michelangelo's activities included inspections and consultations at Pisa and Ferrara, though he seems to have regarded these missions as distractions from his real work at Florence, deliberately contrived by traitors working for a Medici victory. The crisis encouraged Michelangelo's tendency to fits of suspiciousness and anxiety, since in this situation they had an undeniable basis in reality; it would have been surprising had there not been agents and double-agents in the city, as well as a larger number of people who behaved with some ambiguity in the hope of surviving any change of régime. Finally Michelangelo became convinced that the actual commander of the Florentine forces, a mercenary named Maletesta Baglioni, was in the pay of the Medici. He denounced Baglioni to the Signoria, which found no case to answer and rebuked Michelangelo for his excessive

Detail of the head of Giuliano de' Medici, from his tomb in the Medici Chapel. 1526–34. Church of San Lorenzo, Florence.

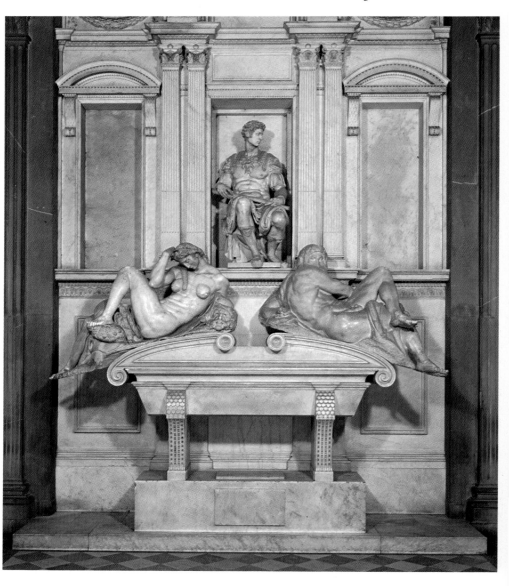

The tomb of Giuliano de' Medici in the Medici chapel. 1526–34. Below the martial Giuliano, seated like a Roman general, lie the figures of Day and Night. Church of San Lorenzo, Florence.

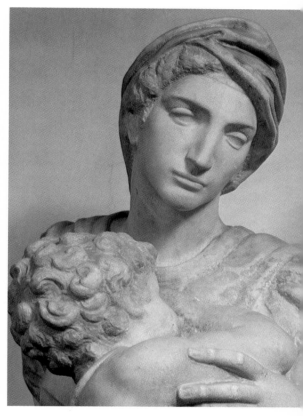

Left: *Madonna and Child* in the Medici Chapel. 1524-34. Michelangelo's last work on this subject. Church of San Lorenzo, Florence.

Above: Detail of the heads of the *Madonna and Child* in the Medici Chapel. 1524–34. In this curious work the Madonna seems to share the melancholy, languid mood of the tomb sculptures; only the vigorously turning child strikes a more energetic note. Church of San Lorenzo, Florence.

fearfulness. Unsettled by the incident, he took to heart a warning that Baglioni intended to have him assassinated, and in September 1529 precipitately fled to Venice, where he seriously thought of taking service with the King of France. When he had calmed down, he realized how bad his behaviour looked and, assured that he would face only token penalties, returned to Florence a few weeks later. He had made himself look foolish, but he was not dishonoured, for he came back at the moment of danger, when the Imperial army was beginning to encircle Florence. He served resolutely throughout the ensuing siege, and is said to have saved the Cathedral tower during bombardments by hanging mattresses round it. Despite famine and plague, the embattled city held out until August 1530, when it was betrayed by – Malatesta Baglioni. Michelangelo therefore had the satisfaction of feeling that his actions had been justified by the event, whether or not the mercenary had actually intended to change sides from the first.

In the new situation his most immediate concern was to survive, and he went into hiding after the Pope's representative took possession of the city. There was no repetition of the excesses committed by the Imperial army at Rome, but many active republicans were hunted down and executed for their 'ingratitude' to Alessandro and Clement. Michelangelo, to whom the Pope had given a regular retainer and a house in Florence, might well have expected to join the victims, but Clement soon sent word that if he would agree to go on with the Medici tombs he should not be harmed. Michelangelo came out of hiding and thankfully submitted.

The republican years were not completely fruitless from an artistic point of view. Michelangelo painted a *Leda*, now lost, for Alfonso d'Este, and may have carved his *Victory* at this time, perhaps for Julius' tomb. His first work after the capitulation is said to have been a figure of Apollo, done to ingratiate himself with Baccio Valori, the Pope's plenipotentiary in newly-conquered Florence.

For the next four years, though contracted to go on with the Medici tombs, Michelangelo seems to have spent as much time as he dared in Rome. The Pope's attitude towards him remained benevolent, but he no longer felt at home in Florence, where Alessandro de' Medici was proving as capricious a tyrant as the Florentines had feared; he also hated Michelangelo, who may have been right in believing that only the Pope's protection ensured his safety. When Clement died in 1534, Michelangelo stayed on in Rome. He never saw his native city again, and the second of his tomb projects was abandoned.

However, the sculptures Michelangelo left behind in the Medici Chapel are still a profound expression of his genius. Ironically, the tombs that stand there commemorate the relatively insignificant Giuliano, Duke of Nemours, and Lorenzo, Duke of Urbino; the remains of the great Lorenzo the Magnificent and his brother lie in a simple chest against the wall opposite the altar. The 'finished' tombs are less elaborate than Michelangelo intended, since he never carved the figures that were to stand in the side-niches and at the base; yet, as so often in Michelangelo's work, the 'accidental' effect is such that we are tempted to suspect an element of deliberate intention. For the austere grandeur of the tombs is completely in harmony with the simple sculpturesque design of the chapel, with its blank panelled walls and dim, dome-lit interior. The central niche in each tomb is occupied by a statue of a Medici, and below this lie two allegorical figures on the actual sarcophagus. The exact meaning of the incomplete scheme will never be known, but the mood is unmistakably one of almost apathetically painful awareness that Time and Death devour all things, including the glory of the Medici. Indeed, the note of glorification is curiously absent. The figures of the Medici are not even portraits but entirely idealized beings in a more or less 'Roman' fancy dress; one is implicitly martial, the other passively absorbed in meditation. When asked why he had not shown the Medici as they were in life (bearded and rather raffish-looking, to judge from other portraits), Michelangelo replied, 'Who will know what they looked like in a thousand years' time?' This was a characteristically laconic and ambiguous retort, which might be taken to mean that he had done the Medici a favour by giving posterity such an ideal vision of them – or that they were irrelevant to the destiny of the work. But behind it lay the simple fact that he disliked portraiture, which was incompatible with the mighty concepts to which he strove to give expression; his preference for the body as a medium of expression sometimes even prompted

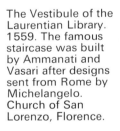

The Vestibule of the Laurentian Library. 1559. The famous staircase was built by Ammanati and Vasari after designs sent from Rome by Michelangelo. Church of San Lorenzo, Florence.

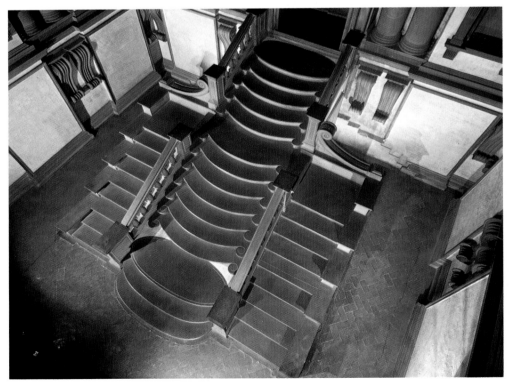

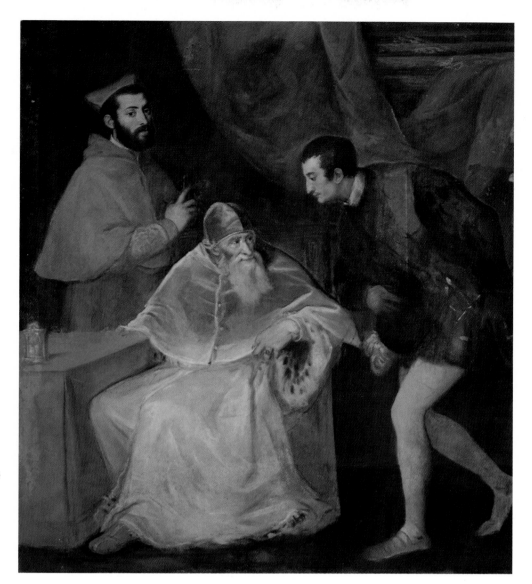

Titian. *Portrait of Pope Paul III and his Nephews*. 1545–46. The 'nephews' – a convenient euphemism – were really Paul's grandsons; the one on the left, Alessandro Farnese, was a cardinal. Although both pope and artist were old men, Paul set Michelangelo a series of tasks that took years to accomplish. Capodimonte Gallery, Naples.

him to pay too little attention to the face and to leave it unfinished or poorly articulated. This is noticeable in the four allegorical figures representing the times of day; *Day* in particular has only a rudimentary head above his superbly muscled body, arranged in a twisted pose of tremendous power. The female figures add to the feeling of unease with which most spectators view the tombs. Michelangelo was uninterested in the female body, and the tomb figures are hardly more than male nudes with breasts unconvincingly attached to their torsos. Strange, slack-breasted *Night* has attracted most criticism on this account, yet there is no doubt that Michelangelo's contemporaries – more alive to the multiple meanings of allegory than we tend to be – were thrilled by this 'perfect' rendering of Sleep and Sorrow. The troubled pagan-allegorical tone of the chapel is hardly disturbed by the *Madonna and Child*, the only other major piece of sculpture carved for the chapel by Michelangelo – and, incidentally, his last sculpted version of the subject. The *Madonna* is a curiously impassive, constricted figure; only the infant Jesus, twisting round vigorously towards his mother, introduces a note of energy into the mournful lassitude of the chapel.

The Laurentian Library was also unfinished when Michelangelo left Florence for the last time. Its most famous feature, the staircase, was finally built in 1559, when Michelangelo was persuaded to make and send a model for it from Rome; it was absolutely unparalleled in its time, seeming to flow down from the library entrance in rippled pools of stone. Such effects were to be characteristic of Michelangelo's practice as an architect. Aiming in true High Renaissance fashion for gravity and grandeur, he did not dramatize (photographs of the staircase tend to mislead in this respect); but he employed columns, arches, domes, pilasters, cornices and all the other features that Renaissance architects had taken over from ancient Rome, without regard for function or the rules of proportion observed in antiquity. Michelangelo shared his contemporaries' passion for the antique, but as both sculptor and architect he made ancient models no more than a starting-point for the expression of his own powerful and idiosyncratic temperament.

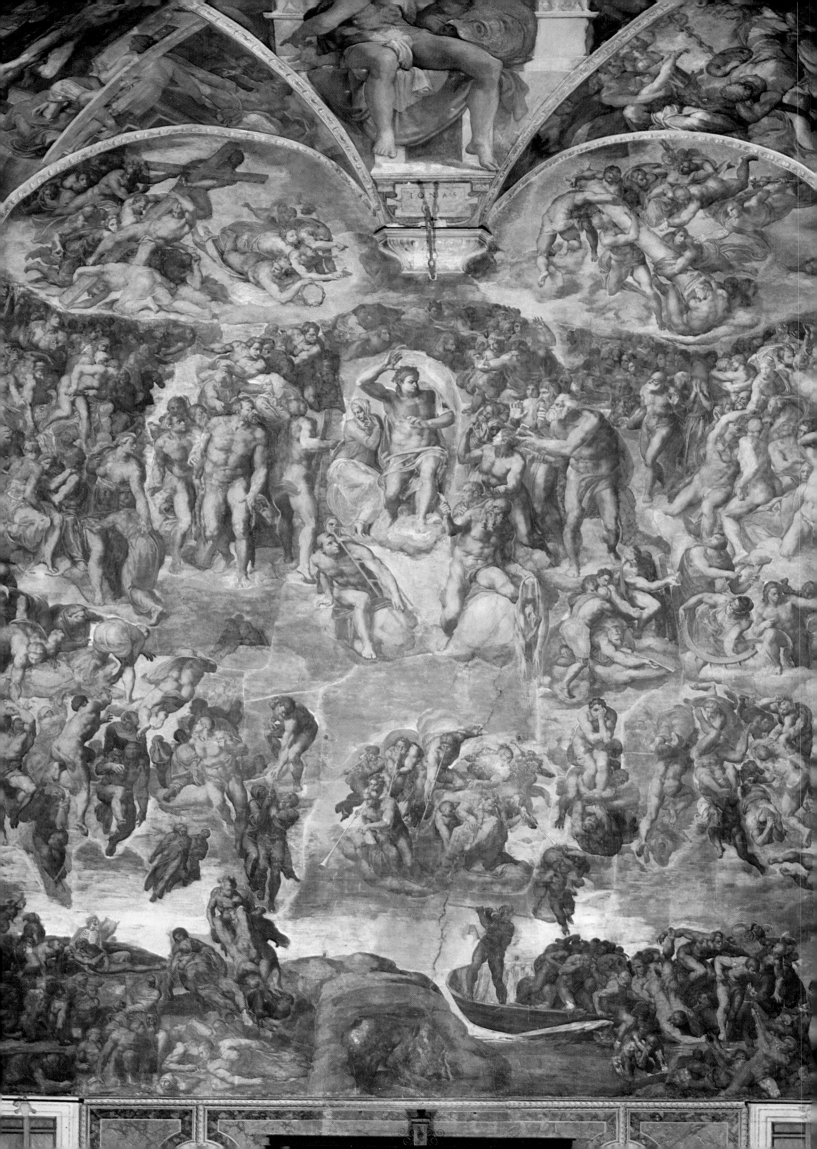

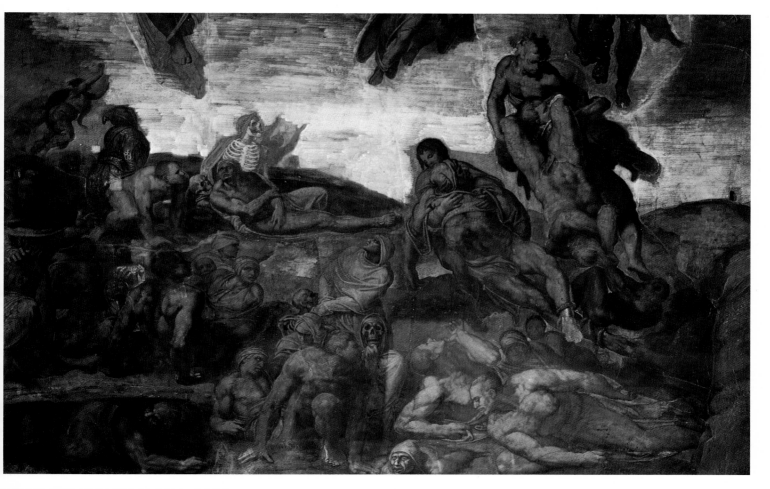

Left: *Last Judgement*. Altar wall painting in the Sistine Chapel. 1535–41. This frightful vision of judgement was painted at the command of Pope Paul III, and reflects the change of mood in Italy since Michelangelo's work on the ceiling almost thirty years earlier. Vatican.

Above, top: Detail from the *Last Judgement* in the Sistine Chapel, showing the resurrection of the dead. 1535–41. Vatican.

Above, centre: Detail of a skull from the *Last Judgement* in the Sistine Chapel. 1535–41. The skull belongs to one of the newly resurrected dead. Vatican.

THE LAST YEARS

When Michelangelo settled at Rome, free of the Medici, he was still hoping to make progress with the figures for Julius' tomb, for which yet another contract had been drawn up in 1532. But the new Farnese pope proved as imperious as any Medici; he had waited thirty years to have Michelangelo in his service, Paul III told him, brushing aside the artist's objections and assuring him that the della Roveres could be made to accept a still less imposing tomb with only three statues by Michelangelo (as in fact happened). After flattering visits to his house by the Pope himself, accompanied by a suite of cardinals, Michelangelo consented. He was rewarded by being named 'Chief Architect, Sculptor and Painter to the Vatican Palace' – an unprecedented title that emphasized his uniqueness and, as it were incidentally, bound him to the papacy.

Michelangelo's first commission for Paul was a *Last Judgement* painted on the altar wall of the Sistine Chapel. Murals by 15th-century masters and two of Michelangelo's own lunette paintings were sacrificed to the creation of a huge fresco that draws the worshipper's eye to it as he enters the chapel and, as he approaches the altar, overwhelms him with a tumultuous, fearful vision of judgement. It is a painting intended to bring men to their knees – and indeed, when the Pope himself saw it, he flung himself down crying, 'Lord, charge me not with my sins when You come in judgement!' The figures on the left-hand side of the fresco are rising up towards Heaven with the aid of wingless angels; but their joy in salvation is subdued by comparison with the anguish of the damned falling on the right-hand side. One of these must be the supreme portrayal of the soul's despair in the history of art, a man with arms crossed and hand over one eye, already so tormented with a realization of damnation that he makes no attempt to resist the grinning demons who drag him down. Other lost souls are spilling out of a boat onto the shores of Hell, driven on their way by Charon, who batters them with his oar. Charon, who ferried the dead across the River Styx, is a figure from Greek myth; he and Minos, King of Hell, are almost the only vestiges of Michelangelo's classicism in the entire work. However, he does portray Christ as naked and beardless in the Classical manner, not bearded and robed in his capacity as judge, yet he nonetheless radiates wrathful judgement. Mary, at his side, averts her gaze from the damned; now that the end of the world has come, she cannot intercede. Christ is surrounded by his saints,

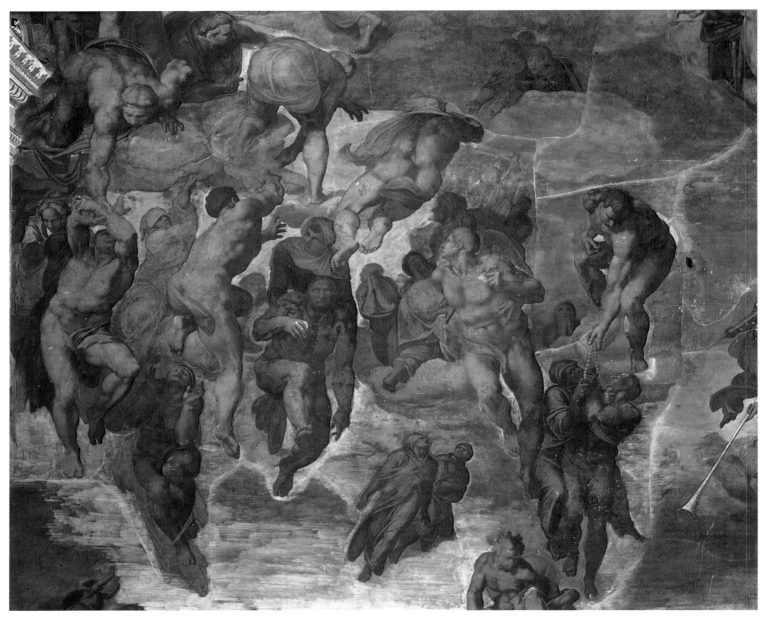

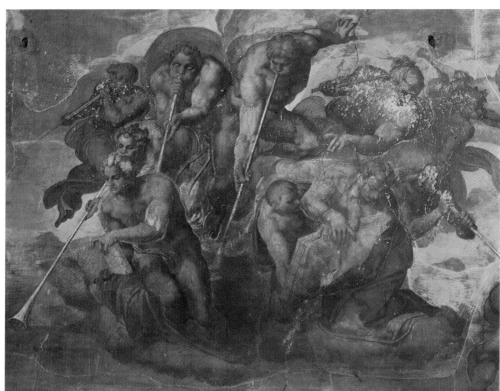

Above: Detail from
the *Last Judgement*
in the Sistine
Chapel, showing the
blessed ascending
to Heaven.
1535–41. The saved
souls are being
carried up to heaven
by angels, whom
Michelangelo
characteristically
portrays as wingless
naked young men.
(The strategically
placed wisps of
drapery were added
by a later hand.)
Vatican.

Left: Detail from the
Last Judgement in
the Sistine Chapel,
showing angels
sounding the Last
Trump. 1535–41.
Vatican.

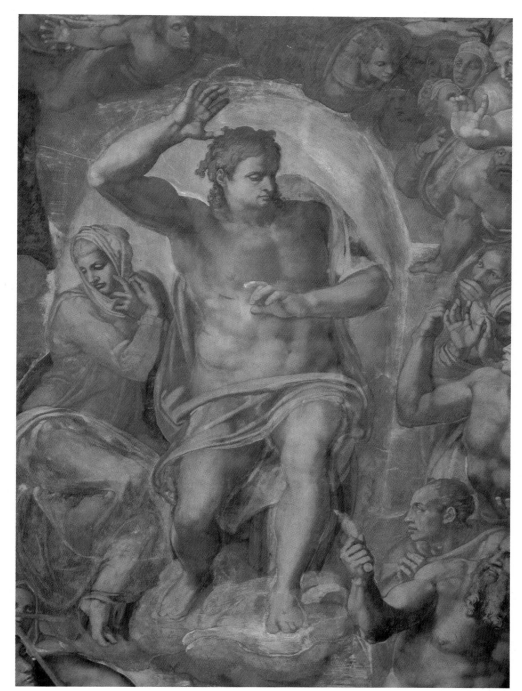

Detail from the *Last Judgement* in the Sistine Chapel, showing Christ with Mary and the saints. 1535–41. Christ is beardless, like a Greek god. Mary looks away from the harsh, ineluctable judgement; her power to intercede has ended with the Last Days. Vatican.

each bearing the symbols of his particular form of martyrdom; St Bartholomew holds a flayed skin on which Michelangelo has depicted his own features in ghastly caricature. Beneath the heavenly host, angels are vigorously sounding the last trump. At the very bottom of the fresco, immediately above the altar, the graves give up their dead (some of them skeletal or only partly-fleshed), and on the other side of the Styx are Charon, the damned and Minos – and the gaping mouth of Hell.

The subject and treatment of the *Last Judgement* reflect the general change of mood. The painting also seems to carry a specific warning to Protestant heretics who dispensed with traditional Catholic practices, for some of the saved are shown as being hauled aloft by a rope – the rosary. Michelangelo clearly shared the general mood; we know from his poems and letters that he became increasingly preoccupied with sin and salvation, and even regretful that he had made a religion of art. In the *Last Judgement* he makes no attempt to glamorize the scene, in the sense that the 'Temptation and Expulsion of Adam and Eve' on the ceiling is glamorized by the beauty of the figures and colours; even the angels in the *Last Judgement* are thick-waisted creatures by comparison with Adam in the ceiling panel, the 'Creation of Adam'. Even so, Michelangelo had not quite kept up with the times, one aspect of which was a growing prudery. The nude figures in the *Last Judgement* shocked the papal chamberlain, Biagio

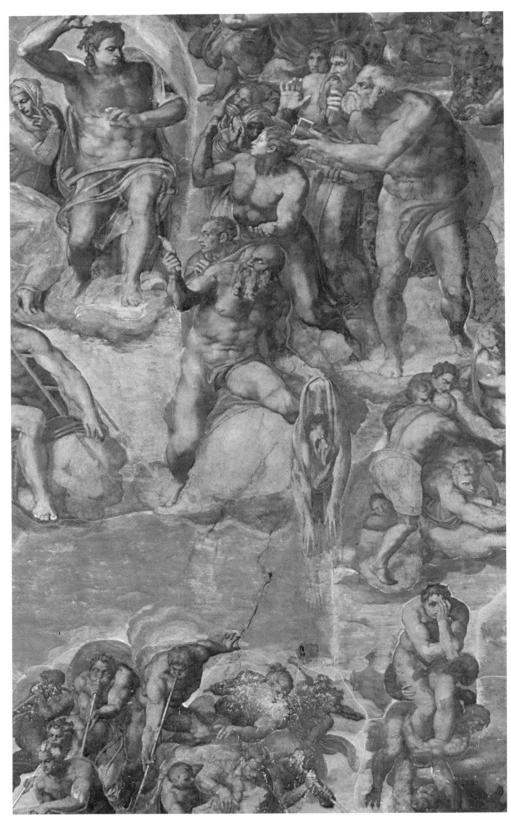

Detail from the *Last Judgement* in the Sistine Chapel. 1535–41. Above, Christ the Judge is surrounded by his saints, each with symbols of his or her martyrdom. Below, angels sound the Last Trump and the damned are dragged down to Hell. Vatican.

da Cesena, who abused the painting, so Michelangelo retaliated by putting him into it, snake-encircled, as Minos. Paul III admired Michelangelo too ardently to support Biagio, but the chamberlain's attitude became increasingly common with the Counter-Reformation reaction against Renaissance 'paganism'. A later pope, Paul IV (1555 – 59), considered destroying the *Last Judgement*, and did send to Michelangelo complaining about the nudity of the figures. The artist replied, 'Tell His Holiness that this is a small matter, easily set right. Let him look to setting the world to order; to reform a picture costs no great trouble.' This characteristic reply, barbed and cryptic, amounted to a grudging consent. One of Michelangelo's assistants, Daniele da Volterra, was therefore employed to cover the offending parts with appropriate drapery, earning the unlucky artist the derisive nickname Daniele Il Braghettone, 'Daniele the Breeches-Maker'.

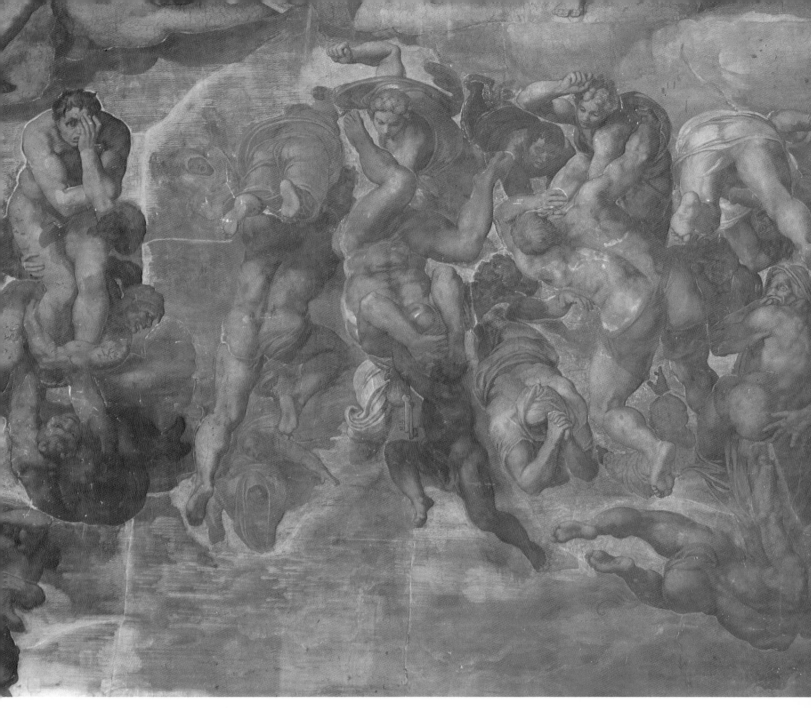

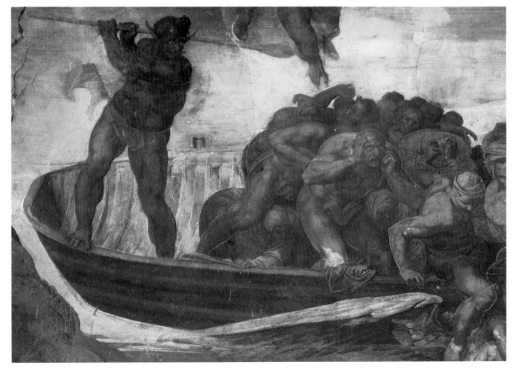

Above: Detail from the *Last Judgement* in the Sistine Chapel, showing the damned being dragged down to Hell. 1535–41. Vatican.

Left: Detail from the *Last Judgement* in the Sistine Chapel, showing the damned being ferried to Hell. 1535–41. Vatican.

Michelangelo began the cartoon for the *Last Judgement* late in 1535 and finished the painting in 1541, a very long period by comparison with his work on the ceiling. One sculpture, a bust of Brutus, may have engrossed some of his attention at this time; since Brutus was a tyrannicide, it was probably suggested by the assassination of the hated Alessandro de' Medici in 1537, and carved soon afterwards. The bust is Roman in both attitude and reference (though a pupil put in the toga and some other touches), representing a last flash of Michelangelo's classicism before Christian piety set him on a somewhat different course.

No doubt he also worked more slowly in his sixties; and it seems that he worked a little less obsessively and enjoyed more company. For much of his maturity he had lived like an ascetic, utterly devoted to his art; now we hear more of dinner engagements and discussions (though the difference may be exaggerated by the mere fact that there were would-be biographers on hand in Michelangelo's old age, eager to make notes of occasions that might earlier have gone unrecorded). Furthermore, in the 1530s, when he was approaching sixty, Michelangelo formed a series of passionate attachments to young men. The most enduring was to a Roman nobleman, Tommaso de' Cavalieri, whom he met on a visit to the city in 1532; the love letters and poems he sent Cavalieri are singularly intense even by the standards of the time, though a large

Jacopo da Pontormo. *Vittoria Colonna.* A portrait of the poet and pietist who deeply influenced Michelangelo in his sixties. Casa Buonarotti, Florence.

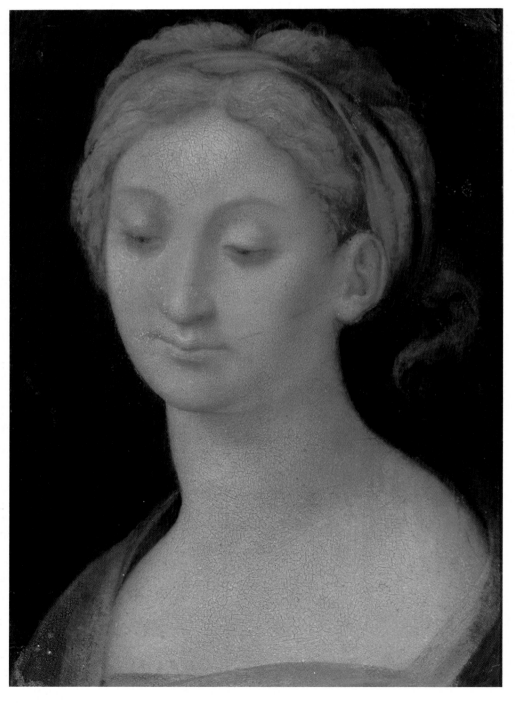

Right: *Brutus.* 1540s. This bust was probably inspired by the assassination in 1537 of Alessandro de' Medici, tyrannical duke of Michelangelo's native Florence. Museo Nazionale del Bargello, Florence.

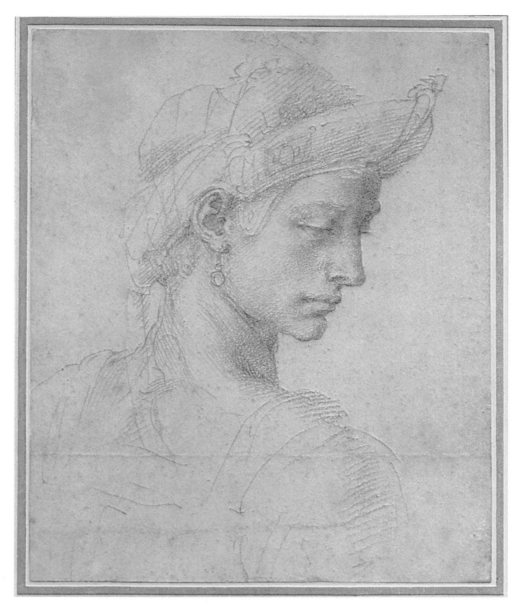

Ideal head. Drawing
in red chalk. *c.*1533.
Ashmolean
Museum, Oxford.

allowance must be made for those standards, and especially for the neoplatonic tendency to equate the physical with the spiritual, and beauty with truth and goodness. However, there is no point in speculating about Michelangelo's sexual activities, since we have no reliable information about them. On the other hand, it is perfectly clear that his temperament was entirely homoerotic; many of his male figures are highly sensual, whereas none of his women are. Significantly, the only portraits he ever condescended to draw were of Cavalieri and another handome youth, Andrea Quaratesi.

The other great friendship of Michelangelo's old age *was* with a woman, but its impulse came from his growing piety. Vittoria Colonna was a well-known devotional poet around whom gathered a group of people interested in religious experience and religious reform. When Michelangelo met her (about 1536) she was in her mid-forties and had already spent ten years of widowhood in religious contemplation; she was probably the chief influence on his thinking until her death in 1547. The nature of Michelangelo's admiration for her is expressed in one of his poems; a man – no, a god – speaks through her woman's mouth, and has robbed Michelangelo of himself . . .

His friendships with Tommaso de' Cavalieri and Vittoria Colonna evidently satisfied different sides of Michelangelo's nature. He wrote poems to both, and also sent beautiful finished drawings to both – crucifixions and *pietàs* to Vittoria Colonna, and mythological scenes in which eagles pounce on young men (with what, to the modern mind, seems transparent symbolic wish-fulfilment) to Cavalieri. These, and a few others like them, are virtually the first examples of drawings consciously produced as works of art. Before Michelangelo's time, the drawing was thought of as a purely functional thing, executed in preparation for a painting or some similar work, and then thrown away when it was done; the

Left: Resurrection. *c.* 1520–25. Musée du Louvre, Paris.

Below: Study: St. Anne. *c.* 1505. Musée du Louvre, Paris.

Above: Crucifixion. *c.* 1550–55. Musée du Louvre, Paris.

Below: *Deposition*. Drawing in red chalk. *c*. 1555. Ashmolean Museum, Oxford.

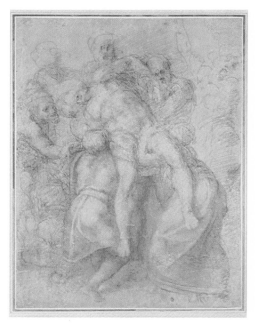

Right: Study of a nude man. Executed in pen. Musée du Louvre, Paris.

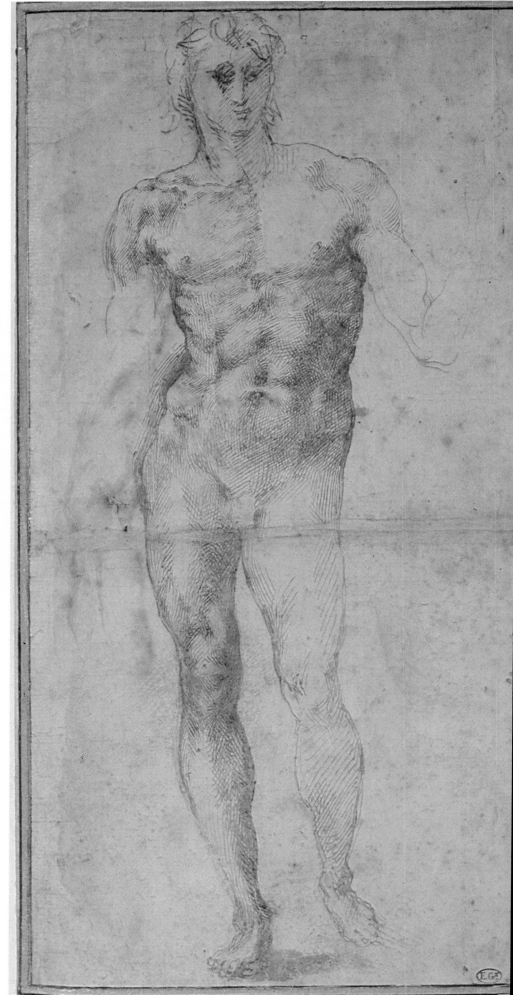

Two nude men fighting. *c.* 1545–50. These figures may represent Jacob and the Angel, or possibly Hercules and Antaeus. Musée du Louvre, Paris.

modern interest in the creative process as such, which makes us treasure the scribbles and sketches of great writers and artists, simply did not exist. But Michelangelo's 'divinity' was such that he (like Leonardo before him) was always being asked, even by kings, for *anything* he cared to produce. (This was another break with the past, making 'a Michelangelo' – not an altarpiece or portrait or civic monument – the desired object.) The only way to satisfy such a demand was through the relatively quick medium of drawing; and so Cavalieri, Vittoria Colonna and a good many others received highly finished works, usually in black or red chalk rubbed until it glowed gently; those who so wished could employ another artist to paint a copy of Michelangelo's original. Some rough sketches and preliminary drawings by him have also survived, though not by his wish; before his death he destroyed quantities of material, preferring not to leave a record of his creative struggles.

At sixty-six, having finished the *Last Judgement* and recovered after a fall from the scaffolding, Michelangelo was still vigorous enough to carry out another large-scale commission for Pope Paul III. Sixtus and Julius had made the Sistine Chapel their memorial; Paul had decided to have one for himself, and ordered Michelangelo to paint two large frescoes in the Vatican's new Pauline Chapel. But the artist would only begin after the Pope had carried out his old promise to settle the business of Julius' tomb; Michelangelo told him that a painter worked with his head, not his hand, and could accomplish nothing if he was distracted by worries – a revealing remark that goes a long way towards explaining Michelangelo's long unproductive periods when engaged on the two tomb projects. The final contract of 1542 reduced Michelangelo's obligations

to manageable proportions; and, as we have seen, he had carried them out by 1545, supplying *Moses*, *Rachel* and *Leah* for the tomb at San Pietro in Vincoli.

Work on the last two of these must partly account for his slow progress on the Pauline frescoes, which were not finished until 1550. The subjects were appropriate to the setting: the *Crucifixion of St. Peter* and the *Conversion of St. Paul*. Peter, the first bishop of Rome, was the rock on which papal authority rested; he is shown in traditional fashion, about to be crucified upside down at his own request, thus expressing his sense of being unworthy to share the fate of Christ. Paul, after whom both Pope and chapel were named, is shown at the moment when – still the persecuting Saul of Tarsus – he has been blinded and flung down by a celestial ray. The oddest of several uncanonical items is that Michelangelo makes Paul an old man, perhaps as some sort of compliment from an old artist to an even older Pope. In both paintings Michelangelo has used brighter colours than in the *Last Judgement*, but all traces of the physical splendour displayed on the Sistine ceiling have vanished; the bodies of the participants are truly of earthly clay, and in setting out the action Michelangelo has aimed at emotional impact rather than realism. The *Crucifixion* is centripetal, with the entire mob of soldiers, functionaries, sympathizers and onlookers turned towards the central figure, whose importance is emphasized

This page: *The Crucifixion of St. Peter*. 1545–50. Michelangelo's last painting, in the heavy but highly expressive style of his old age. According to tradition St. Peter asked to be crucified upside down, feeling himself unworthy to share Jesus' fate. Detail right. Pauline Chapel, Vatican.

Lower right: *The Conversion of St. Paul*. 1542–45. This large fresco, like its companion-piece, *The Crucifixion of St. Peter*, was painted for Pope Paul III's chapel. It shows the moment when the Pope's namesake, the apostle Paul, blinded by a bolt of heavenly light, is reproached by Christ for persecuting his followers. Detail far right. Pauline Chapel, Vatican.

Overleaf: Interior of St. Peter's, Rome, looking down the nave towards the altar.

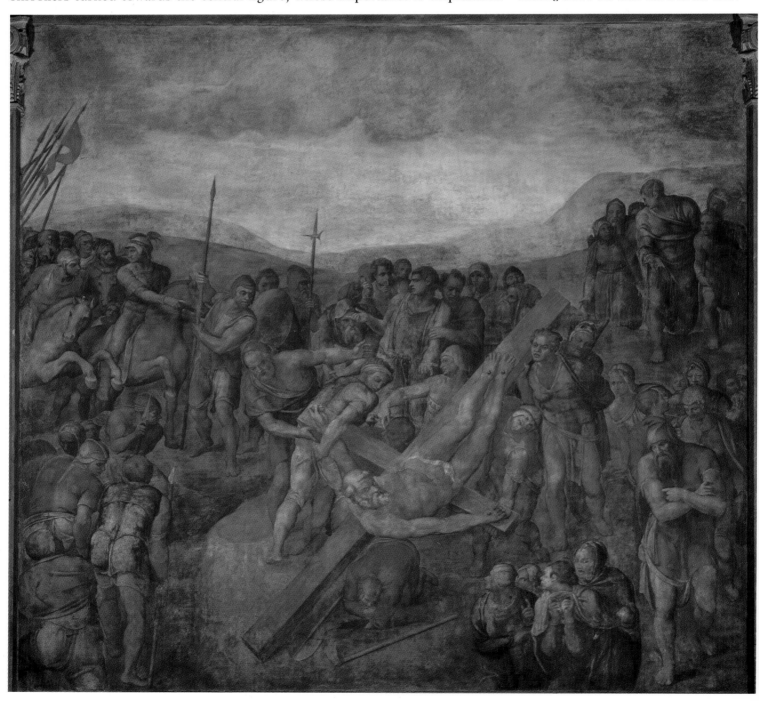

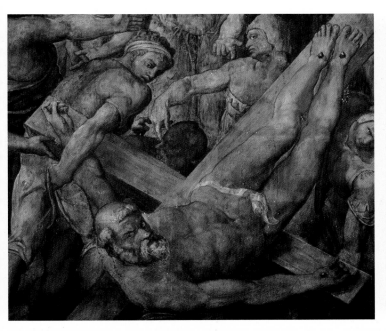

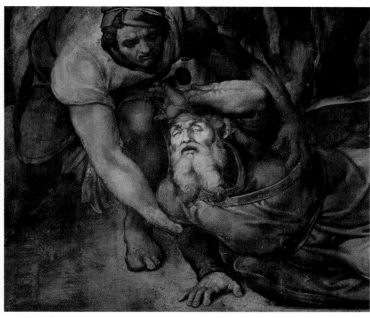

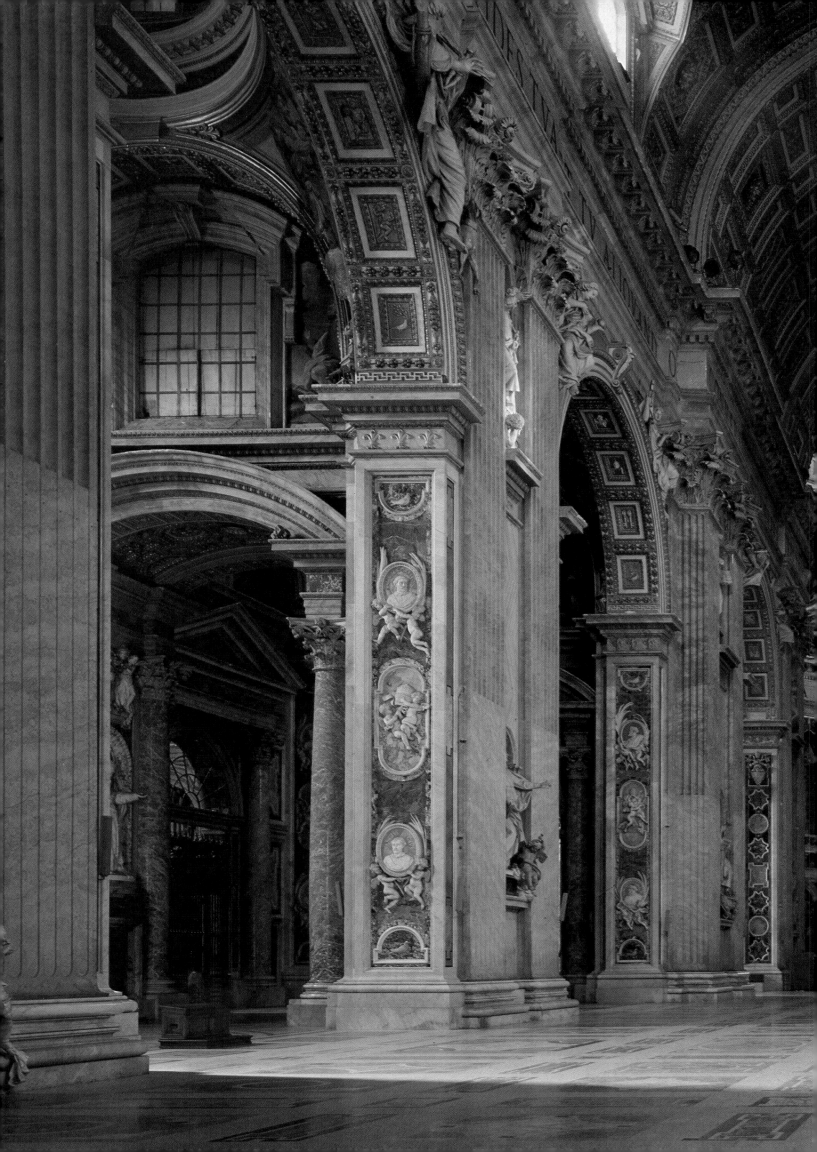

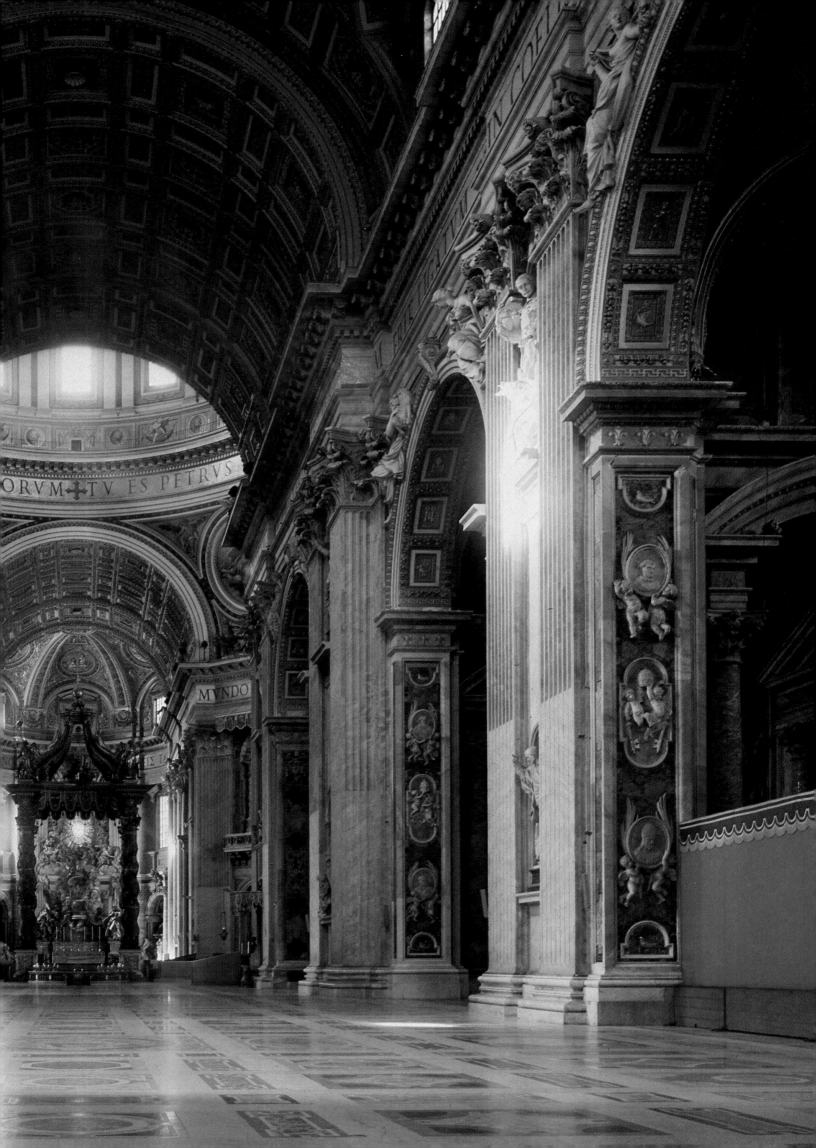

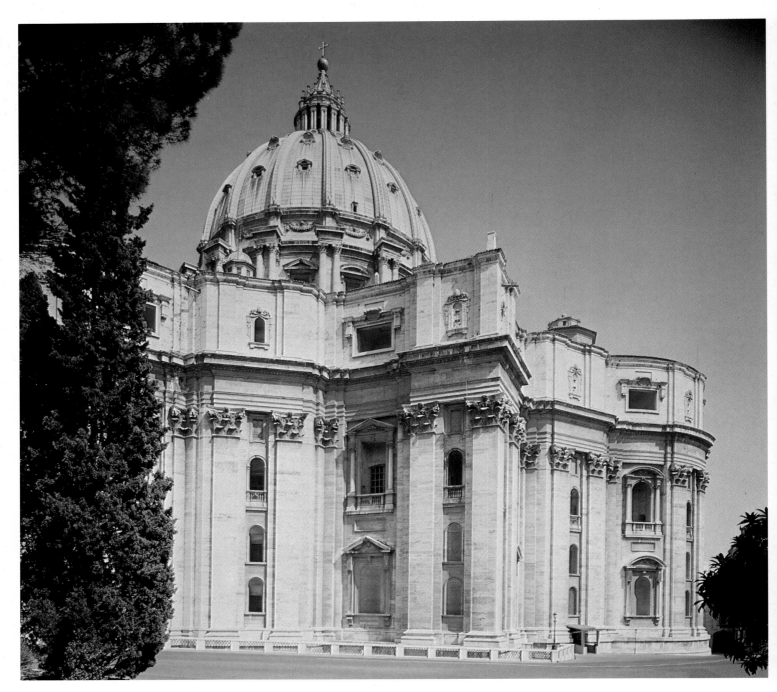

St. Peter's, Rome. Michelangelo was the chief architect of St. Peter's for the last eighteen years of his life (1546–64), but the building went on for generations after his death and much of his work has become integrated with that of others. Only when viewed from this angle, from which the nave and other later features are invisible, can we get some idea of Michelangelo's original design.

through the bold diagonal made by the cross; only Peter himself twists round and looks straight at the spectator with an angry, accusing glare. In the *Conversion* the effect is reversed: the bolt of blinding light links the Messiah and his apostle-to-be while flinging Saul's companions away in almost visible lines of force.

Even before the frescoes were finished, Michelangelo had assumed a new responsibility. In 1546, on the death of the papal architect Antonio da Sangallo, Paul III persuaded Michelangelo to take over Sangallo's unfinished projects. One of these was the splendid but vastly expensive Farnese Palace, erected to glorify the Pope's family. Sangallo had built two-thirds of the main façade and courtyard, but Michelangelo altered the plans for the upper storey, which he completed in his own more idiosyncratic style.

He also took over from Sangallo as chief architect of St. Peter's, an office he held until the end of his life, despite the fact that for long periods he was not well enough to supervise work on the spot; in the event, he outlived Paul and three further popes, successfully warding off all challenges to his authority. That authority was all the stronger for Michelangelo's refusal to accept payment for his work, which was done, he said, solely for the glory of God. The challenges came mainly from cronies of Sangallo whom Michelangelo found no use for; indeed his opinion of his predecessor was low, and he tore down much that Sangallo had done. In essentials he returned to Bramante's plan, thus tacitly

honouring the long-dead enemy who had caused 'the tragedy of the tomb' (so
Michelangelo believed) by persuading Julius to concentrate on building St.
Peter's. But the work went slowly, thanks to its expense, intrigues, shortcomings
and Michelangelo's infirmities. St. Peter's was not to be finished in his time, or
for several generations; perhaps appropriately, the greatest of all Christian
churches was not to be the achievement of a single man. At Michelangelo's
death, only the drum – the base on which the dome would rest – was completed;
and when the dome was eventually built, it was to specifications rather different
from his. Furthermore, the whole appearance of St. Peter's was transformed by
later additions. Bramante and Michelangelo visualized it as a compact central-
planned church, essentially symmetrical in layout; but later architects added a
nave, a façade and a great sweeping colonnade that diminish the visual impact
of the dome and create a dramatic impression quite different from what Michel-
angelo had in mind. Great as his contribution to St. Peter's was, only part of it
can be appreciated by the non-specialist – the exterior wall around the back of
the building, where the play of light on the alternating wide and narrow bays
reveals the hand of the sculptor-turned-architect.

Architecture evidently took the place of sculpture in Michelangelo's old age,
enabling him to go on shaping stone without the relentless physical labour of
carving. Of his other architectural commissions, the most notable was to lay out
the Piazza del Campidoglio, a site rich in historical associations since it had been

*The Rondanini Pietà. c.*1552–64. Michelangelo was working on this sculpture during the last week of his life. The elongated, rough-hewn figures of Mary and Jesus create an extraordinary impression; it is hard to believe that the work would have gained in emotional impact by being finished. Museo dei Castello Sforzesco, Milan.

the sacred Capitoline Hill of ancient Rome. Michelangelo's plan for the piazza was not finished until a century after his death, but what we see today is essentially his conception. Approached by a ramp, enclosed by splendid buildings, and focused on the Roman equestrian statue of Marcus Aurelius within its oval-geometric pattern, the piazza is a justly celebrated feat of town-planning.

Even in extreme old age, Michelangelo did not entirely abandon sculpture. A French visitor describes him working with great force and assurance, slicing away thick fingers of stone with astonishing precision – but one suspects that the visitor was either being treated to a virtuoso performance or was so overwhelmed by meeting the great man at all that he imagined what he wanted to see. From the late 1540s Michelangelo was working on a *Deposition* for his own tomb, but either became dissatisfied with it or uncovered a flaw in the marble. He smashed it in anger, but later permitted one of his assistants to patch it up. To us, this work is perhaps all the more moving for being unfinished and broken; it is certainly not out of harmony with the subject – the broken body of the dead Christ, just taken down from the cross, being supported by his

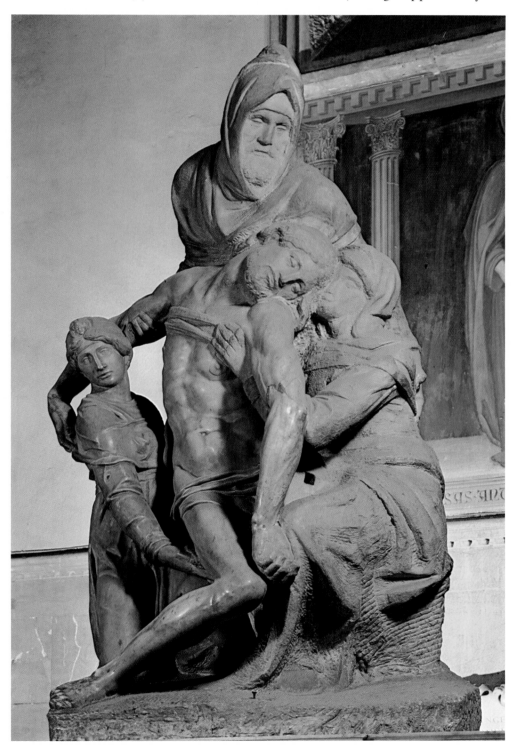

*Deposition. c.*1547. A damaged work (Christ has only one leg) which Michelangelo originally intended for his own tomb. It is often, wrongly, called a *Pietà*. The hooded figure of Nicodemus is said to be a self-portrait. Duomo, Florence.

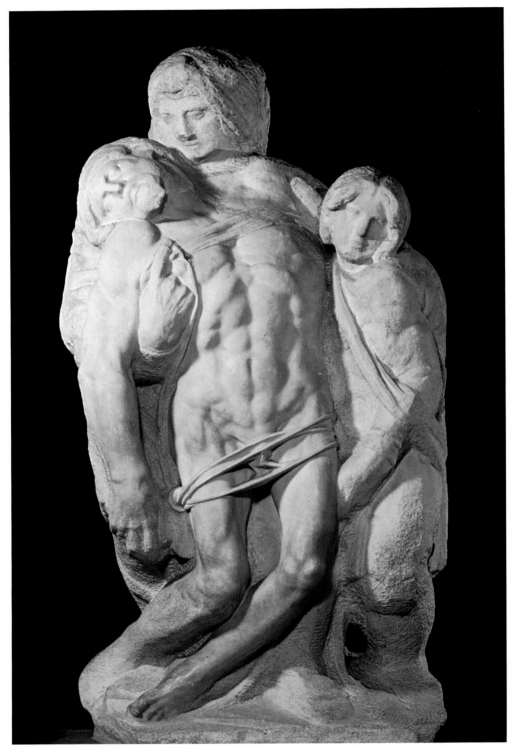

*The Palestrina
Deposition. c.*1556.
An unfinished late
work whose
authenticity has
been disputed.
Accademia,
Florence.

mother, Mary Magdalene and Nicodemus (a hooded, compassionate figure whose face is said to be Michelangelo's self-portrait). The last of all Michelangelo's works, now known as the *Rondanini Pietà*, is still more rudimentary; yet, probably by accident, it also appeals to modern taste. In it the long sorrowful shapes of Mary and the dead Christ tell us all, without further detail or articulation; if the statue had been carved in the 20th century we might well praise it for eliminating non-essentials.

Though often ill, Michelangelo remained vigorous to the end; we know that in the last week of his life he worked on the *Rondanini Pietà* and also went out riding. When he died, on 18 February 1564, he was buried with great solemnity in the Church of the Holy Apostles in Rome . . . and then his body was stolen and smuggled out of the city by some Florentine merchants, so that it could be re-buried in his native soil, in the Church of Santa Croce. Grotesque as this ending was, it indicated the divinity – or rather the artistic sanctity – that Michelangelo had attained, when his bones could be disputed over as if they were holy relics.

Acknowledgments

Ashmolean Museum, Oxford 66; British Museum, London 33 bottom; Cooper-Bridgeman Library, London 37 right; Cooper-Bridgeman – Phaidon 71 top left, 71 top right; Courtauld Institute of Art, London 33 top; Hamlyn Group Picture Library 20, 29 right, 39, 40 top, 41 left, 41 right, 42 top, 42 bottom left, 43 bottom, 48 right, 61, 63 top, 68 left, 70, 71 bottom, 74; Musées Nationaux, Paris 7, 48 left, 49; Photographie Giraudon, Paris 15, 32, 67 top, 67 bottom left, 67 bottom right, 68 right, 69; Scala, Florence 8, 9, 11, 13, 14, 16, 17, 18, 19, 21, 22, 23, 24, 25 top left, 25 top right, 25 bottom, 26 left, 26 right, 27, 28, 29 left, 30, 31, 34, 35, 36 left, 36 right, 37 left, 37 centre, 38, 40 bottom right, 42 bottom right, 43 top, 45, 46 top, 46 bottom, 47, 50, 51 left, 51 right, 52 top, 52 bottom, 53 left, 53 right, 54 left, 54 right, 55 left, 55 right, 56, 57, 58, 59 top, 59 bottom, 60 top, 60 bottom, 62, 63 bottom, 64, 65, 72–73, 75, 76, 77, 78, 79; Ziolo/Held, Paris 40 bottom left.

Front cover: Detail of *David*. 1501-4. Galleria dell' Accademia, Florence. (Scala, Florence)
Back cover: 'Christ and the Virgin'. 1535-41. Detail from the *Last Judgement*, Sistine Chapel. (Hamlyn Group Picture Library)
Endpapers: 'Day and Night', detail from the tomb of Giuliano de' Medici. 1526-34. Medici Chapel, Church of San Lorenzo, Florence. (Scala, Florence)
Title spread: *Resurrection of Christ*, 1531. *Wilde Collection*, British Museum. (Cooper-Bridgeman Library, London)

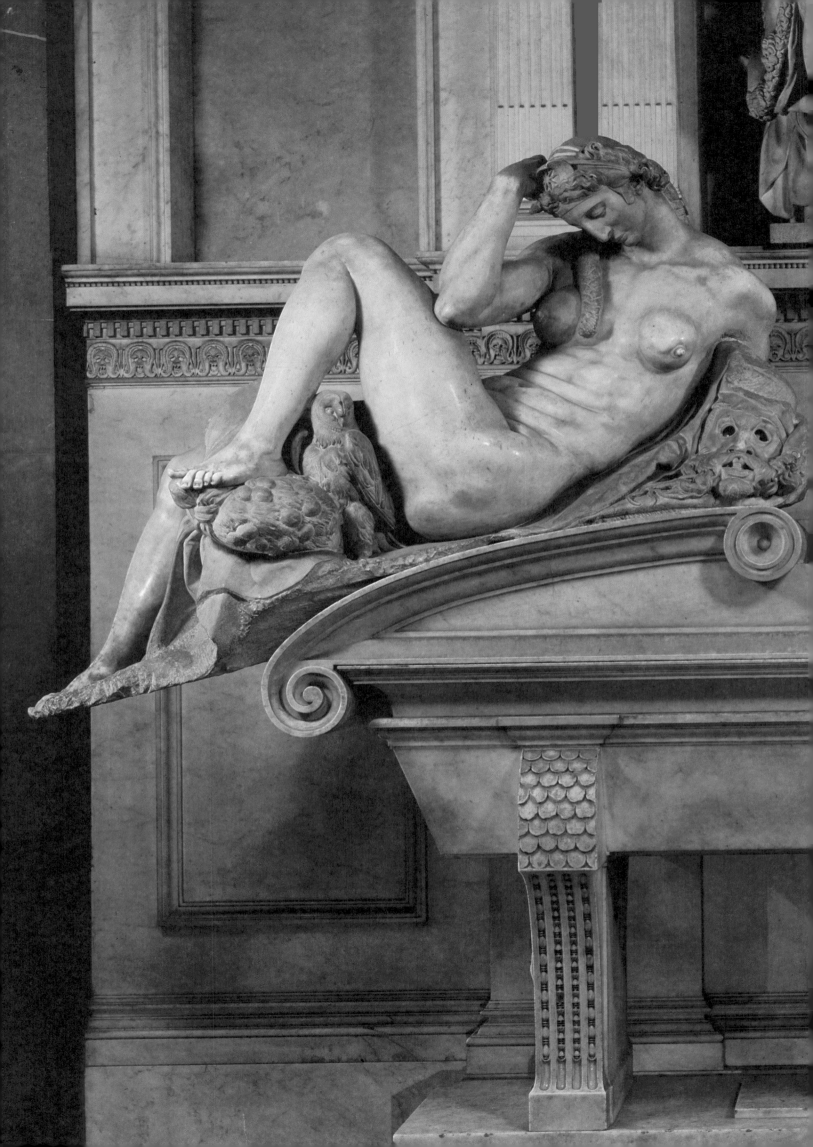